IMAGES
of America

LOWELL
OBSERVATORY

IMAGES
of America

LOWELL
OBSERVATORY

Kevin Schindler

ARCADIA
PUBLISHING

Copyright © 2016 by Kevin Schindler
ISBN 978-1-4671-3417-0

Published by Arcadia Publishing
Charleston, South Carolina

Printed in the United States of America

Library of Congress Control Number: 2015945764

For all general information, please contact Arcadia Publishing:
Telephone 843-853-2070
Fax 843-853-0044
E-mail sales@arcadiapublishing.com
For customer service and orders:
Toll-Free 1-888-313-2665

Visit us on the Internet at www.arcadiapublishing.com

This book is dedicated to the memory of William Lowell Putnam III, longtime sole trustee of Lowell Observatory.

CONTENTS

ACKNOWLEDGMENTS

Many individuals contributed to this book, some knowingly, some not. The late William Lowell Putnam III was a strong proponent of recording the history of Lowell Observatory. Another deceased but hardly forgotten scholar, William Graves Hoyt, wrote two volumes about Lowell history and was working on a third when he passed away. The efforts of these two, in particular Hoyt, laid the groundwork for other researchers such as Mars and Percival Lowell expert William Sheehan, whose lively discussions about observatory history added much perspective. Michael Kitt's ongoing support of historical research helped spur this project. Sue Durling's financial support of other projects inspired the completion of this one.

Observatory director Jeffrey Hall, astronomer Larry Wasserman, and particularly volunteer coordinator Mary DeMuth, who read through an early draft, provided reliable editing suggestions. Observatory archivist Lauren Amundson and curator Samantha Thompson helped track down images and background information. Volunteer John Spahn scanned many of the images from original prints in the Lowell archives. Unless otherwise noted, all photographs appear courtesy of the Lowell archives. Other sources include Patricia Bridges, who also shared her memories of working on the moon mapping project; the Johnson Space Center History Collection (listed as JSC History Collection); the University of Arizona Library Special Collections; and Corbis Corporation.

Current sole trustee William Lowell Putnam IV has been encouraging with projects such as this, critical to making this book a reality. Numerous past and present public program staff members, who have shared in spreading the word about the observatory's ongoing legacy of discovery, ultimately inspired the creation of this book. Members of the Flagstaff Corral of Westerners unwittingly spurred this project on by their collective passion for history. Alyssa Jones at Arcadia Publishing helped get this project off the ground, and Lily Watkins and Henry Clougherty patiently saw it through. Finally, but mostly, Gretchen Schindler was simply magnificent in her support, from scanning images to offering encouragement when needed most. To all of these people and others who enjoy the story of Lowell Observatory, thank you.

INTRODUCTION

At the age of 39, Percival Lowell founded an astronomical observatory that would profoundly impact humanity's view of the cosmos. The year was 1894, and since then, the observatory has seen its share of cutting-edge research and front-page discoveries. From new worlds and an expanding universe to the search for Martian life and mapping of our nearest neighbor for the first space voyagers, the résumé is a long one.

Yet these transcendent moments are just part of the story. There is also the everyday lunch box research carried out over time, whose end result is not a singular momentous discovery but a gradual collection of data that builds a base of knowledge of how the universe works.

The main characters of the story are not just the scientists, technicians, and other support staff who have often foregone a normal lifestyle in the interest of scientific pursuit; the main characters also include the telescopes themselves, those tools of the trade that seem to take on personalities of their own.

This book starts with an introduction to the remarkable Lowell clan, who came to America in the 1600s and developed into one of the leading families of the Northeast, Boston Brahmins to the bone. Members of the family would make their marks in fields such as literature, education, business, and the sciences. Scion of this family, Percival Lowell founded his astronomical observatory in Arizona, fulfilling his part in keeping the family name relevant. The Putnams, kin of the Lowells, took over leadership of the observatory nearly a century ago, guiding it into periods of intense growth and success.

Andrew Douglass helped Lowell establish his observatory, traveling by train and stagecoach across the Arizona Territory in 1894, searching for the ideal site from which to view the stars. Douglass visited Tombstone, Tucson, Tempe, and Prescott before stopping—and staying—in Flagstaff.

The early days of the observatory were dominated by Percival Lowell's Mars research, which focused on apparent markings on Mars called canals that indicated to Lowell the presence of some form of intelligent life. Mars would remain a topic of interest for future observatory scientists, though with a different focus than the canals. E.C. Slipher even made expeditions to South Africa to get the best possible views of Mars.

Beginning in 1905, Percival Lowell began searching for a new planet beyond Neptune. He spent the last 11 years of his life periodically working toward fulfilling this quest. He led a team that made mathematical calculations to determine its location and then used a variety of telescopes to carry out a photographic search. Lowell died without finding his planet, but his vision paid off for the observatory in 1930, when 24-year-old Clyde Tombaugh discovered Pluto.

Three decades later, the world waited as humans left Earth for the first time to walk on another world. Nowhere was the interest greater than at Lowell, where for years a dedicated team of cartographers created detailed maps of the lunar surface using airbrushes. They worked closely with telescope observers in making more than 100 maps of the moon, some of which the astronauts carried with them on their era-defining journeys.

The observatory has served as home to dozens of scientists through the years, many whose names are relegated to the footnotes of history. Some of them spent their entire careers at Lowell, happy to be working where the expectation to achieve was matched by a freedom to pursue research of their choice. Others stayed for a short time but still contributed to the legacy of Lowell.

Like any tradesman, an astronomer is only as good as his or her tools. Percival Lowell purchased the best telescopes money could buy, such as the 24-inch Clark refractor. But he also realized that a telescope's worth often goes well beyond its price. The instrument had to be well suited for its intended research, which meant not always buying the most expensive instruments but those best designed for his needs.

All of this research, the people doing it, and the instruments they used make for a great story. But it would not be complete without including a look at the personality of the organization as represented by the variety of houses and other buildings not generally associated with a business, because Lowell is much more than just a workplace. It also has served as home to dozens of staff and their families since the observatory's beginnings.

Then there is the nickname for the mesa on which the observatory stands. When Percival Lowell established his research center in Flagstaff, the hilltop was soon labeled Observatory Mesa on maps. But locals took to calling it Mars Hill, in recognition of Lowell's Mars research. This is more than an impersonal label handed out for convenience; it is a term of endearment shared by Mars Hill residents and nonresidents alike.

All these factors together—the scientists and support staff, their legacy of both groundbreaking and foundation-strengthening research, the telescopes involved, and the personality of Mars Hill—make for a compelling story hard to match anywhere else.

To include all of the scientists and support staff from Lowell's past and all of the observations and discoveries they have made would make this book daunting both to write and read. Because of this, and also considering the nature of this book series, this volume mostly covers the people and events dating back at least 50 years. Some exceptions occur, when it seemed appropriate to finish a story even though it drifted into a more modern era. Also, because this is a book that relies on photographs, some topics are not discussed simply because photographic records do not exist. Let those mentioned here, then, represent the greater population of scientists and their diverse bodies of work, and let this book be a testament to those who came before and those yet to come.

Finally, Percival Lowell wrote in his 1906 book *Mars and its Canals*, "To set forth science in a popular, that is, in a generally understandable, form is as obligatory as to present it in a more technical manner. If men are to benefit by it, it must be expressed to their comprehension." This volume is a testament to that mind-set of sharing knowledge and building awareness. *Non lucror, exposita scientia, ad astra.*

One

THE LOWELLS TALK ONLY TO CABOTS

In 1639, Englishman Percival Lowle, an assessor for the Earl of Berkeley, brought his family to the New World and settled in Newbury, Massachusetts. The spelling of the name soon changed to Lowell and over the next three centuries, this lineage was one defined by prestige, intellectual achievement, diverse ambition, and wealth. The family is recognized as one of the Boston Brahmins, a nickname for the long-standing upper class of New England, and is venerated in this toast: "Here's to Good Old Boston / The Home of the Bean and the Cod / Where the Lowells talk only to Cabots / And the Cabots talk only to God."

The family's motto, *occasionem cognosce*, means "know your opportunity." Individual family members made many, often revolutionary, contributions in a number of different fields: business, the arts, philanthropy, science, and education. Some of the roles in which they served include federal judge, university president, architect, Pulitzer Prize–winning poet, diplomat, industry leader, military leader, and writer.

Percival Lowell, scion of this family, was born in 1855. While his position as eldest son traditionally would have dictated he stay in Boston to assume the position of family patriarch, he spent much of his adult life elsewhere. His younger brother Abbott Lawrence would be the one to continue the family's strong family presence in their hometown.

When Lowell established his astronomical observatory in 1894, he duplicated the organizational structure of another family entity, an educational foundation known as the Lowell Institute. A defining element declared singular control by a sole trustee, rather than a traditional board. Percival followed this structure because he wanted management of the organization to stay within the family.

He established a rule that the current sole trustee designates a successor immediately after taking office. Percival Lowell never had any children to whom he could pass the torch, so initially turned to his brother-in-law (and distant cousin) William Lowell Putnam to help with financial matters. Putnam never officially served as sole trustee, but his direct offspring did. In fact, a member of the Putnam line has served as sole trustee for three-quarters of a century.

John Lowell, the "Old Judge" (1743–1802), was a founder of the American Academy of Arts and Sciences, appointed to the federal bench by George Washington, and died while serving as chief justice of the First Circuit Court of Appeals. He had three sons, John the "Rebel" (1769–1840), Francis Cabot (1775–1817), and "Reverend" Charles (1782–1861). Each of these family lines left an important mark on history.

The Old Judge's third son, Charles, was father of prominent poet and diplomat James Russell Lowell (1819–1891), shown here. James Russell was one of the Fireside Poets, a group of 19th-century poets who incorporated conventional patterns of rhyme and meter in creating pieces popular for memorization in school and at home. Other members of the group included Henry Wadsworth Longfellow, Oliver Wendell Holmes, William Cullen Bryant, and John Greenleaf Whittier.

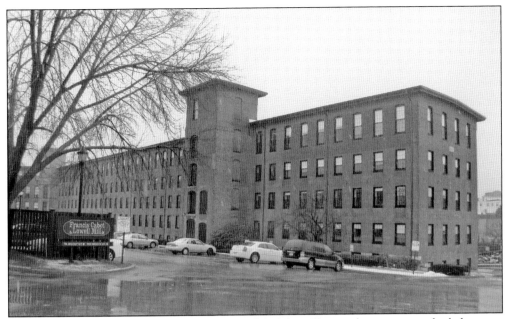

The Old Judge's second son, Francis Cabot Lowell (1775–1817), was a businessman who led a group of investors in creating the country's first major industrial corporation, the Boston Manufacturing Company. In Waltham, Massachusetts, this company built America's first integrated textile mill (which now serves as housing for seniors). Boston Manufacturing later built a mill town along the Merrimack River, naming it Lowell in honor of Francis.

Francis Cabot Lowell's eldest son, John (1799–1836), pictured here, bequeathed in his will money to establish the Lowell Institute, a unique organization dedicated to offering public lectures about science, religion, and other topics of interest. The institute was overseen by a sole trustee, who was also a member of the Lowell family. This organizational plan served as a model for Percival Lowell's observatory.

The Old Judge's first son, John, was the father of John Amory Lowell (1798–1881), prominent in the family textile business. John Amory's youngest son was Augustus Lowell (1830–1900), pictured here. Augustus took the family fortunes to their highest levels. He married Katharine Lawrence (the city of Lawrence, Massachusetts, is named after her family) and had five children, Percival (1855–1916), Abbott Lawrence (1856–1943), Katharine (1858–1925), Elizabeth (1862–1935), and Amy (1874–1925).

Dressed in girls' clothing in the late 1850s (a common custom of the time), a young Percival Lowell (right) and his brother Abbott Lawrence pose for a photograph. By this time, Percival had already been exposed to astronomy; he later recalled seeing Donati's Comet—the second-most brilliant comet viewed from Earth in the 19th century—at the age of three.

As an adult, Abbott Lawrence Lowell was a scholar and educator. Known for his progressive policies, he served as president of Harvard University from 1909 to 1933. He led the university through an era of expansion that saw significant increases in the number of students, amount of funding, and physical capacity. His bust (shown here) sits in the main courtyard of Harvard's Lowell House, which honors the entire Lowell clan.

Amy Lowell, shown here, was Percival's youngest sibling and an avid reader all her life. An outspoken, cigar-smoking poet, she was one of the leaders of the imagist school of poetry, identified by its use of precise visual images. In 1926, a year after her death, she was posthumously awarded a Pulitzer Prize for her book *What's O'Clock*.

William Lowell Putnam II (1861–1924) was a lawyer, banker, and Percival Lowell's third cousin. In 1888, he married Percival's sister Elizabeth, pictured here with William. Putnam managed many of the Lowell family finances and later would oversee Lowell Observatory operations from 1897 to 1901, when Percival was ill. Several of his descendants would ultimately serve as sole trustees of Lowell Observatory.

Percival Lowell's mother gave him his first telescope when he turned 15. At the family's Sevinels home (so named because of the seven Lowells living there) near Boston, Percival set the instrument up on the roof to observe the night sky. He later brought it with him to Flagstaff. In this photograph, the telescope sits on the porch of the Baronial Mansion, Lowell's home at his observatory.

After graduating from Harvard with a degree in mathematics in 1876, Percival Lowell worked in the family textile business for several years. In 1883, he traveled to the Far East and lived for the next 10 years in Korea and Japan, writing several books about Eastern culture and the occult. He also served as diplomat for a Korean trade delegation, shown here in an 1883 photograph.

Percival Lowell, left, entertained a wide circle of literary and artistic friends. One of them, Harvard classmate Ralph Curtis (1854–1922), right, had studied law at Harvard but then moved to Paris to train as a painter. He is best remembered for his landscape pieces, but he also painted portraits and interior scenes. Here, Curtis visits Lowell in Tokyo about 1883.

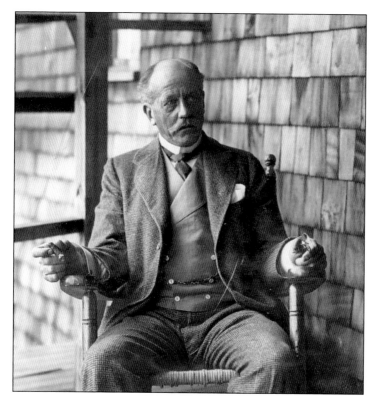

After 10 years in the Far East, Percival Lowell moved back to the United States. Inspired by astronomer Giovanni Schiaparelli's intriguing Martian discoveries, Lowell soon turned his attention to his boyhood interest of astronomy. In 1894, he established the observatory in Flagstaff, Arizona, that still bears his name. In this photograph, Lowell sits on the porch of the Baronial Mansion.

In 1908, Percival Lowell, then 53 years old, married a Boston neighbor, Constance Savage Keith (1863–1954), then 44 years old. This marriage apparently came as a surprise to most people who knew Lowell. After he died in 1916, Constance challenged his will, trying to reduce the amount of money he had designated for the observatory. The matter was finally settled after a 10-year battle in probate court.

Percival Lowell enjoyed a good cigar and once said, "The only reason for dinner is the fine cigar that follows." In this early 20th-century photograph Lowell holds, in typical pose, a book in one hand and cigar in the other while gazing out the window of his study in the Baronial Mansion. Much of the furniture, equipment, and other items visible in this image remain at the observatory today.

Percival Lowell was an engaging speaker and promoter of science. In many ways, he was the Carl Sagan of his time, offering provocative explanations for natural phenomena and inspiring the lay public to learn more about the universe around them. While much of the scientific community doubted Lowell's claims, particularly about life on Mars, he spurred many on to either prove or disprove these theories.

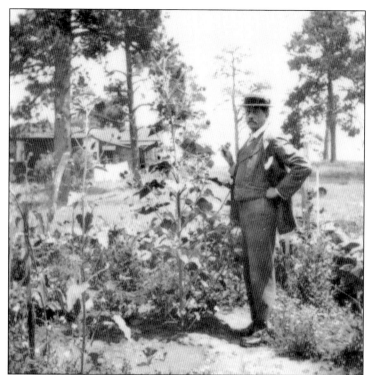

Percival Lowell was an amateur botanist, often collecting plant specimens and sending them to Charles Sprague Sargent at Harvard's Arnold Arboretum. Sargent named a new species of ash tree *Fraxinus lowelii* in honor of Percival, who had discovered the first known specimens. Lowell also kept a vegetable garden at his observatory, located just downhill from the Baronial Mansion (visible to the left in this image).

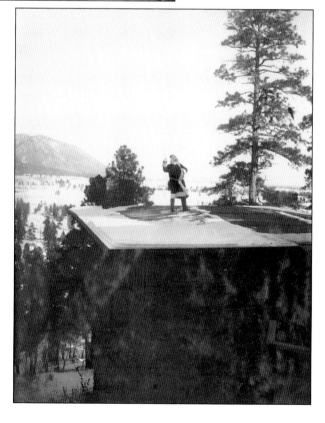

Percival Lowell regularly celebrated holidays with his staff at the observatory, sharing dinners and exchanging gifts. On Christmas Day 1911, he donned a Santa Claus outfit, complete with a bearded face mask. In this photograph, he stands on the roof of the old library near the Baronial Mansion, with Mount Elden visible to the far left.

The Grand Canyon is 70 miles north of Flagstaff, and on several occasions Percival Lowell took guests to see this natural wonder. In this photograph, he hikes along the Bright Angel Trail with his good friend, zoologist and Orientalist Edward Morse (1838–1925). Morse was a staunch supporter of Lowell's theories about life on Mars, evidenced in Morse's 1906 book *Mars and Its Mystery*.

Percival Lowell enjoyed mountain climbing and is seen here in the San Francisco Peaks near Flagstaff. At the time of his death, Lowell was president of the Appalachian Mountain Club, a group founded by Edward C. Pickering (1846–1919) in 1876. Pickering later served as director of the Harvard College Observatory and advised Lowell when he was planning to build his observatory in Flagstaff.

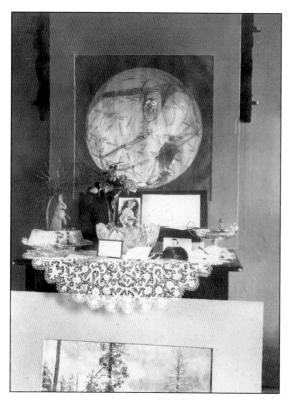

While Percival Lowell was intense and driven, he also had a warm side, which resulted in heartfelt devotion and friendship among many of his staff members. On Lowell's 53rd birthday, staff presented him with a variety of presents, shown here. Of particular note is the cake topped with a rabbit—Lowell loved wildlife—and one of Lowell's drawings of Mars.

Percival Lowell enjoyed life at the observatory. In this magnificently silhouetted image, he sits on the veranda of the Baronial Mansion enjoying breakfast. In fact, when the weather permitted and he was in town, he would take many of his meals here, allowing him to enjoy the surrounding forest landscape. Lowell died at this beloved Flagstaff abode on November 12, 1916, at the age of 61.

One of Flagstaff's earliest cars was Percival Lowell's 1911 Stevens-Duryea touring automobile, which he drove while sightseeing around northern Arizona. In 1938, his widow, Constance, got rid of the car. Half a century later, observatory sole trustee William Lowell Putnam III repurchased it and returned it to the observatory, where it is on display when not being driven in parades.

Guy Lowell (1870–1927), shown in this charcoal sketch, was a third cousin of Percival Lowell. He was a well-known architect who designed such structures as the Boston Museum of Fine Arts and the New York State Supreme Court building in New York City. He served as observatory sole trustee from the time of Percival Lowell's death in 1916 until his own death in 1927.

Roger Lowell Putnam (1893–1972), pictured here with his wife, Caroline, was the middle of the five children of William Lowell Putnam II. Roger was a businessman and politician, serving as mayor of Springfield, Massachusetts. He succeeded Guy Lowell as the observatory's sole trustee in 1927 and served in that capacity for 40 years. During his tenure, he was instrumental in establishing Lowell Observatory's Anderson Mesa dark-sky site.

Roger Putnam's youngest son, Michael Courtney Jenkins Putnam (b. 1933), on the far right, professor of classics at Brown University, was the sole trustee from 1967 to 1987. Michael's older brother William Lowell Putnam III (1924–2014), second from right, served in that role from 1987 to 2013. The latter was an alpinist, broadcaster, and writer. Joining them in this picture are, from left to right, Earl Slipher and his cousin David Slipher.

Two

ABANDON CITIES AND FOREGO PLAINS

By 1893, Percival Lowell had become quite familiar with the research of Italian astronomer Giovanni Schiaparelli, who had detected linear features on Mars that he called *canali*, Italian for channels. Percival Lowell and others believed these features were just too precise to be natural and so must be the work of some form of intelligent Martian life.

This intrigued Lowell, and in 1893 he decided to build his own astronomical observatory specifically to study Mars and this supposed evidence of intelligent life. After conferring with astronomers at Harvard College Observatory, Lowell determined he should not build his facility at traditional locations near Eastern cities, since the recent proliferation of artificial light was brightening the skies. Instead, he would build in the sparsely settled Arizona Territory, where light pollution was not a problem.

Lowell hired a young astronomer named Andrew Douglass to travel to Arizona with a telescope and other scientific equipment for studying the sky. Douglass's mission was to haul the equipment to various sites around the territory and test their atmospheric conditions. By doing this, he could find an ideal site for Lowell to build his observatory.

On March 7, 1894, Douglass arrived in Arizona Territory with two coffin-sized boxes in tow. The strange-looking crates contained a seven-foot-long brass telescope and its wooden supporting tripod.

Douglass carried out observations at 14 different stations in Tombstone, Tucson, Tempe, Prescott, and Flagstaff. Often experiencing primitive travel, lodging, and observational conditions, Douglass nonetheless learned much valuable information about both the quality of astronomical viewing and local politics, both of which would be important factors in establishing an observatory. Based on these findings, Percival Lowell chose Flagstaff as the site for his observatory.

The 1894 expedition to Arizona Territory was thus an important and seminal endeavor for Arizona, as it led to the founding of the first permanent scientific establishment in Flagstaff and the first astronomical research facility in Arizona, both of which helped establish Arizona as a premier location for scientific research.

Andrew Douglass (1867–1962), shown here in his later years, was the perfect person to carry out Percival Lowell's site-testing expedition. A graduate in astronomy from Trinity College, he learned about site testing while on a trip to Peru under the guidance of William Pickering (1858–1938) of Harvard College Observatory, younger brother of that observatory's director, Edward. Years after helping Lowell found his observatory, Douglass established the science of dendrochronology (tree-ring dating).

Douglass began earnestly testing sites in Tombstone, where he stayed from March 7 to 11. At three locations in the area, he set up the telescope to gather data, a practice he would repeat at each testing site throughout the expedition. This image, taken more than a century later, shows the telescope and tripod much as they appeared during the expedition.

The second Tombstone station was at the Grand Central Mine dump, shown here. To move the bulky telescope, tripod, and associated scientific equipment from station to station during the expedition, Douglass often relied on local residents, who were usually very curious and quite happy to help. (University of Arizona Library Special Collections.)

From March 11 to 16, Douglass explored three sites in Tucson and drew this map to indicate their relative locations. Sentinel Peak is better known today as A Mountain, where University of Arizona students still paint a large letter A every year. Turtleback is now referred to as Tumamoc Hill and is a site for anthropological research. (University of Arizona Library Special Collections.)

Douglass took a train from Tucson to Tempe and stayed there from March 17 to 27. He tested two different locales on Tempe Butte, shown in this image. Today, Tempe Butte, like Sentinel Peak in Tucson, features a large man-made letter A (in this case it stands for Arizona State University) and is also known as A Mountain. The university's Sun Devil Stadium sits on the side of Tempe's A Mountain. (University of Arizona Library Special Collections.)

From Tempe, Douglass traveled to Prescott via a stagecoach over the Black Canyon Highway, a treacherous road. However, he had to send the large boxes holding the telescope and its tripod by train, because the stagecoach driver refused to load the boxes, which he thought looked like coffins. Douglass tested two sites in Prescott between March 28 and April 3. (University of Arizona Library Special Collections.)

Douglass arrived in Flagstaff on April 3 and tested a site (station 11) just west of downtown, on top of a mesa overlooking Flagstaff's largest lumber mill, the Arizona Lumber & Timber Company. He later tested three more sites in the area, as indicated on this map he sketched: a hill near A1 Ranch, Elden Mountain, and Wing Mountain.

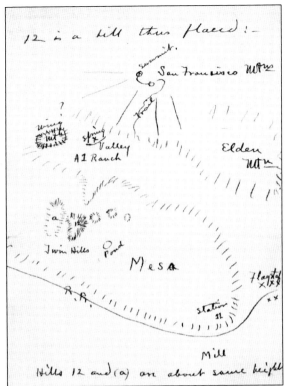

Douglass befriended Denis "Matt" Riordan, who owned the mill, and his half brothers, Tim and Michael, who eventually bought Matt's interest. The brothers were civic-minded community builders who understood the value of bringing a scientific research facility to town. In this image, the mesa on which Douglass established station 11 rises to the left while a ghostly Elden Mountain stands in the background. (Cline Library, Special Collections and Archives Department.)

This photograph from the late 19th century was taken from near station 11 and shows the extensive lumbering facility, which has long since been removed. Today, Days Inn along West Route 66 would be visible from this view.

Douglas drew this contour map weeks after first arriving in Flagstaff. It shows the relative locations of the mill and station 11 (designated as "6 in" for the six-inch telescope Douglass was using) at the lower left and the eventual spot chosen to set up a telescope dome for long-term use (indicated by "Obsy"). The 24-inch Clark telescope dome now sits at this location.

This is a view of station 11 on the mesa above the Riordan brothers' lumber mill. A boy stands next to the six-inch telescope assembly partly covered with fabric. Douglass ultimately decided to build the observatory about half a mile north of here because the side of the mesa was much too steep to build a road.

This view of station 11 shows the proximity of the telescope to the southern edge of the mesa, which drops precipitously from here. This relatively flat table of rock typically rises 200 to 400 feet above the surrounding land and was created approximately 300,000 years ago by a volcanic lava flow. Today, the mesa is known by locals as Mars Hill or Observatory Mesa.

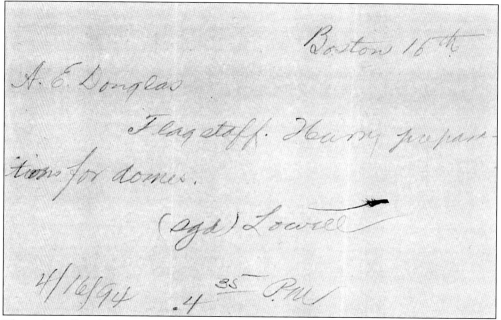

Throughout Douglass's site-testing expedition across Arizona Territory, he kept in constant contact with Percival Lowell back in Boston via telegrams and letters. By mid-April, Lowell had seen enough reports from Douglass about the various sites he had tested and on April 16 sent this telegram to Douglass, directing him to build the observatory in Flagstaff. The body of the telegram reads, "Flagstaff. Hurry preparations for domes."

This is the only known photograph of the coffin-shaped wooden boxes in which Douglass transported the six-inch telescope and its tripod during the expedition. Shown here are Flagstaff locals Ed Whipple (1856–1939), left, and Jim Laurfont, who assisted Douglass with much of the site testing in the Flagstaff area. (University of Arizona Library Special Collections.)

NUMBER	SENT BY	REC'D BY		CHECK
475	Mc	Je 10th		

RECEIVED at *Flagstaff 12 u* 4/21 1894

Dated *Boston Mass 21*

To *A. E. Douglass*

Select eleven telegraph Tombstone Tucson for letters apparatus hurry work

Lowell

By April 21, 1894, Lowell was anxious to begin construction of his observatory. While Douglass wanted to continue testing more sites, Lowell instructed him otherwise in a telegram: "Select eleven telegraph Tombstone Tucson for letters apparatus hurry work." Douglass thus began preparing for the arrival of the main telescope and its dome and within five weeks would have the observatory up and running.

For carrying out research at his new observatory in Flagstaff, Percival Lowell borrowed an 18-inch telescope from Harvard College Observatory and a 12-inch instrument from the Pittsburgh lens maker John Brashear (1840–1920). In this photograph, workmen unload the tube of the 18-inch at the site of the observatory. The instrument had originally been sent to Tucson but was later shipped to Flagstaff.

Flagstaff resident and business owner Ed Whipple came to the area in 1880 and was a jack-of-all-trades, serving as a saloon keeper, carpenter, deputy sheriff, and undertaker during his nearly six decades in northern Arizona. He also assisted with various construction projects around town, including the dome to house the 18- and 12-inch telescopes at the new observatory. Here, he sits on the tube of the 18-inch telescope.

On April 23, 1894, Andrew Douglass and a crew of helpers broke ground on the new telescope dome. He shared news of the ground breaking in this telegram to Percival Lowell, which reads, "Ground Broken town gives land and builds road Ephemeris received." The land Douglass referred to was five acres deeded to the observatory by the town of Flagstaff.

Harvard College Observatory astronomer Edward Pickering and his younger brother William advised Percival Lowell on many aspects of the new observatory. William also designed the dome to house the 18- and 12-inch telescopes. The stationary base of the structure, consisting of cedar posts and planks, was built on-site in Flagstaff and measured 34 feet in diameter.

The top moveable portion of the dome was built in Cambridgeport, Massachusetts, and sent to Flagstaff in pieces. Weighing approximately 3.5 tons, it was comprised of a wooden frame covered with wire netting, over which was stretched painted canvas. It featured an eight-foot-wide shutter of unpainted canvas that was easily opened for telescope viewing.

Boston telescope builder Alvan Graham Clark (1832–1897) designed a special mount to simultaneously hold both the 18- and 12-inch telescopes. Lowell and his staff began observing through the 12-inch on May 31, 1894, and the 18-inch the following evening. These telescopes were used at the observatory until April 3, 1895, after which they were returned to their owners.

Several Flagstaff concerns, including the Flagstaff Board of Trade, supported the observatory from the beginning, offering to donate land, build roads, and help in any other way possible. This letter from D.J. Brannen, president of the board of trade, demonstrates this support and gratitude for Lowell's choice of Flagstaff as site for the observatory.

THE WESTERN UNION TELEGRAPH COMPANY.

INCORPORATED

21,000 OFFICES IN AMERICA. CABLE SERVICE TO ALL THE WORLD.

This Company TRANSMITS and DELIVERS messages only on conditions limiting its liability, which have been assented to by the sender of the following message.
Errors can be guarded against only by repeating a message back to the sending station for comparison, and the Company will not hold itself liable for errors or delays
in transmission or delivery of Unrepeated Messages, beyond the amount of tolls paid thereon, nor in any case where the claim is not presented in writing within sixty days
after the message is filed with the Company for transmission.
This is an UNREPEATED MESSAGE, and is delivered by request of the sender, under the conditions named above.

THOS. T. ECKERT, President and General Manager.

NUMBER	SENT BY	REC'D BY			CHECK
55 Ex	7G	P	13 Pd		

RECEIVED at 109 State Street, BOSTON. 3/6 Pm 5/4 1894

Dated Flag-Staff a 7 4

To Percival Lowell 850 Exchg Bldg
Boston

Code received two dates, Cordialite
Copetana Chincapins, Corollary Corrodante
Chaperonne, Veritable Concambio Veneration

Douglass

As Douglass was spearheading the observatory construction effort, he also continued astronomical studies. This seemingly incoherent telegram is in fact a coded message from Douglass to Lowell, giving the coordinates of a comet that Douglass had observed. Lowell insisted on the coding to prevent outside parties from learning about the location of the comet before he could officially report it.

In this 1898 photograph, Andrew Douglass (right) is joined on the San Francisco Peaks by a Mr. Ferguson. Even though Douglass had completed an initial site-testing effort in 1894, he continued testing the skies at other locations for several years. Here, he uses the six-inch telescope—with modified tripod—and an anemometer (a device for measuring wind speed) to collect data.

This 1898 photograph shows Douglass (to the left, in pith helmet) standing next to the six-inch telescope during a site-testing survey on the San Francisco Peaks. Three other men and a tent are also visible in this image. This site may have been visited during the same trip to the San Francisco Peaks shown in the previous photograph.

In this 1898 image, Douglass stands next to the remains of a large wood-mounted canvas disc on the San Francisco Peaks. As part of an experiment to evaluate resolution, Douglass had previously erected the disc so he could view it from the observatory. Years after Douglass's site-testing efforts on the San Francisco Peaks, observatory staff would set up a temporary field station at the top of Doyle Peak.

Three

THE BEST TELESCOPE MONEY CAN BUY

While Percival Lowell was content to borrow telescopes for his initial year of research in Flagstaff, in 1895 he decided to purchase a large telescope of his own to continue his efforts. At the same time, he began searching for a new site for his observatory, as Flagstaff had seen a lot of snow in that first year of operation, limiting the nights for observing available. Furthermore, Mars would make a close approach to Earth in 1896, normally an excellent time for viewing. From Flagstaff's vantage point, however, Mars would also be quite low in the sky. A lower-latitude site, with a correspondingly higher position for Mars in the sky, would offer even better viewing.

In April of that year, Lowell ordered a new 24-inch refracting telescope from Alvan Clark and Sons, the preeminent telescope makers of their time. Meanwhile, Andrew Douglass found a new site near Mexico City that would offer milder winter weather and a more favorable viewing angle of Mars.

The telescope was finished in July and then sent to Flagstaff, where Douglass and a team of workers temporarily installed it in the old borrowed dome, which had stood empty after Douglas returned the 18- and 12-inch telescopes to their owners. This allowed staff to test the telescope before sending it, along with its own dome, down to the Mexico site.

Lowell and his team used the telescope in Mexico for about nine months, primarily observing Mars. Lowell then directed Douglass to take the telescope and dome back to Flagstaff and use them there. The rest, as they say, is history. Since the spring of 1897, the telescope has been in constant use—save for a 1.5-year renovation project during 2014 and 2015—first for research and then in recent decades for educating the public.

Some of the significant research done with the Clark included Percival Lowell's controversial Mars studies, V.M. Slipher's detection of the expanding nature of the universe in 1912, and moon mapping for the Apollo program in the 1960s and early 1970s.

On April 25, 1895, Percival Lowell and telescope maker Alvan G. Clark signed this agreement. It called for Clark's firm to build a 24-inch refracting telescope for $20,000. The new instrument arrived in Flagstaff 14 months later and saw first light on July 23, 1896. It would prove to be one of the best refracting telescopes—from an optical standpoint—ever built.

Percival Lowell hired Godfrey Sykes (1861–1948) to design and build a dome to house the new 24-inch telescope. At the time, Godfrey and his brother Stanley (1865–1956) owned a bicycle repair shop (pictured below) in downtown Flagstaff and claimed to be "makers and menders of anything." While Godfrey eventually moved from Flagstaff, Stanley would work at the observatory for the rest of his life and establish family roots in town.
On April 25, 1895, Percival Lowell and telescope maker Alvan G. Clark signed this agreement. It called for Clark's firm to build a 24-inch refracting telescope for $20,000. The new instrument arrived in Flagstaff 14 months later and saw first light on July 23, 1896. It would prove to be one of the best refracting telescopes—from an optical standpoint—ever built.

Percival Lowell hired Godfrey Sykes (1861–1948) to design and build a dome to house the new 24-inch telescope. At the time, Godfrey and his brother Stanley (1865–1956) owned a bicycle repair shop (pictured below) in downtown Flagstaff and claimed to be "makers and menders of anything." While Godfrey eventually moved from Flagstaff, Stanley would work at the observatory for the rest of his life and establish family roots in town.

The Sykes brothers built the upper rotating portion of the dome on an empty lot next to Godfrey's home, located at the corner of Dale and Humphreys Streets in Flagstaff (shown here). They then disassembled it, put it on a train with the telescope, and sent it down to Mexico. They would build the walls on-site in Tacubaya, near Mexico City.

The disassembled telescope and dome arrived in Mexico on December 5, 1896, and a crew of 20 workers unloaded it a few days later. By December 21, the workers had reassembled most of the components and now added the roof to the dome, which was covered on its sides with canvas. This thin material allowed for efficient equalization of the ambient temperature outside with that inside the dome.

Percival Lowell arrived in Mexico with the telescope's objective lens on December 28. By that evening, workers had installed it into the telescope tube and commenced observations. Not until January 18, however, was the telescope and dome assembly working properly. Lowell and his team observed in Mexico for several months, until March 26, 1897, when the telescope and dome were returned to Flagstaff.

Earth is spinning on its axis, resulting in the illusion that the stars are moving around it. A celestial object viewed through a telescope will thus quickly move out of the field of view unless this motion is counteracted. This is accomplished with a mechanism called a clock drive. The Clark's first clock drive was wound by hand, as demonstrated in this photograph of the telescope in Mexico.

In this photograph taken in Mexico around 1897, Andrew Douglass sits in the Clark telescope dome, peering at a celestial object. The dome was later modified after workers returned it to Flagstaff. For instance, the canvas of the roof was eventually replaced by wood overlaid with metal, and a stepped pit was added to the floor to allow easier access to the eyepiece.

Percival Lowell and his team used this observing ladder while viewing through the Clark telescope in Mexico and later for a short time in Flagstaff. Shown here is Wrexie Leonard (1867–1937), who not only served as Lowell's personal secretary for 20 years but also made numerous observations, particularly of Mars, through the Clark telescope. In 1923, several years after Lowell's death, Leonard wrote a heartfelt biography about him.

The Clark telescope and its dome were returned to Flagstaff in April 1897 and reassembled on the same spot where the dome housing the borrowed 18- and 12-inch telescopes had stood. Pictured here c. 1897, Andrew Douglass sits on a chair in the doorway of the dome with two unidentified men. The slatted white box next to Douglass houses a weather station.

Pictured here around 1897 is the interior of the Clark telescope dome after it was returned to Flagstaff. This wide-angle photograph nicely shows the details of the dome: pitted wooden floor, wooden walls, canvas dome sides, and wooden dome roof. The cables, weights, and metal wheel to the right of the telescope pier are part of the clock drive assembly.

In 1898, workers replaced the canvas siding of the dome with more weather-resistant wood. This would later be covered with sheet metal to offer the best possible protection against Flagstaff's frequently harsh weather. The framework visible on top of the dome was added to facilitate opening the dome shutters, which were originally made of canvas. (University of Arizona Library Special Collections.)

Initially, the Clark dome was perched on 20 iron wheels that turned on a track. A rope ran around the outside of the dome and connected to a drum. That drum's axle extended inside the dome and attached to a wheel, shown in this photograph taken in Mexico about 1897. Observers such as Wilbur Cogshall (left) and Thomas J.J. See (right) moved the dome by turning this wheel.

When the dome's canvas was replaced with wood, workers struggled to move the dome because of the added weight. In early 1899, Andrew Douglass came up with a solution: position the dome on top of pontoons—shown here on the ground—and float the dome in a trough of saltwater. This effort failed miserably, so the original system, with modifications, was reinstalled around 1901.

Observers viewed from a variety of platforms and chairs through the years. In November 1900, Andrew Douglass rigged this swing chair, attaching a myriad of cables to keep it stable. The chair was impractical and soon discarded. (University of Arizona Library Special Collections.)

Many telescope domes feature an elevator floor to lift the observer to the eyepiece, but the Clark dome never did. When the eyepiece was especially highly placed, as in this photograph, staff assembled a platform from which to view. Pictured here sometime between 1901 and 1905, Percival Lowell sits precariously 20 feet in the air, with access to the platform via two temporarily placed ladders.

Percival Lowell sits on the observing ladder that would permanently reside in the Clark dome. This is perhaps the most iconic photograph of Lowell, likely taken by Philip Fox, director of the Dearborn Observatory in Evanston, Illinois. In this image, Lowell is peering through the Clark telescope at Venus during an October 17, 1914, afternoon viewing session.

The Clark telescope's objective lens consists of two 24-inch-diameter discs of glass held in a cast-iron cell about four inches apart. The lens needs to be cleaned periodically to remove dust, pollen, and other foreign debris that accumulates over time. In this photograph, taken sometime between 1901 and 1905, Percival Lowell (wearing hat) joins astronomer V.M. Slipher (holding lens) and machinist Stanley Sykes in cleaning the lens.

The Clark telescope's aperture had to be opened to its full 24-inch extent when viewing faint objects such as galaxies. Conversely, to avoid overexposure when viewing bright objects such as planets, it had to be "stopped down" to reduce the amount of incoming light. For years, observers did this by placing wooden squares with different-sized holes (against the wall to the left) over the aperture.

Staff eventually designed a more efficient method of adjusting the amount of incoming light to the Clark. A knob at the eyepiece end of the telescope was attached to a wooden dowel that extended to the other end and controlled an iris diaphragm. By turning the knob, the operator could open the diaphragm to the full 24-inch limit or close it down to a diameter of six inches.

This staff photograph was taken in 1905 and shows the recently added interior wall of the Clark dome. From left to right are Harry Hussey (dome porter), Wrexie Leonard (secretary), V.M. Slipher (astronomer), Percival Lowell, Carl Lampland (astronomer), and John Duncan (astronomer). Slipher and Lampland both spent their entire professional careers at Lowell Observatory, while the others worked here for periods ranging from three to 20 years.

On June 14, 1966, officials of the National Park Service designated Lowell Observatory a registered National Historic Landmark. Lowell director John Hall, seated, served as master of ceremonies while trustee Roger Putnam accepted a certificate and bronze plaque from the National Park Service on behalf of the observatory. Putnam is pictured here unveiling the plaque, which still stands in front of the Clark telescope dome.

The Clark telescope is celebrated today not only for its scientific legacy and educational impact, but also for its quirky charm. Since 1960, its dome has rotated on Ford automobile tires, leaving the structure with some problems unique to any other dome in the world. Flat tires, for instance, must be changed periodically, as seen in this 1990s photograph with engineer Ralph Nye (left) and machinist Jim Darwin (right).

Four

THE MYSTERY OF MARS

Percival Lowell established his observatory in 1894 initially to study Mars and the possibility of intelligent life there. His interest in Mars remained for the rest of his life, and he regularly observed and wrote about it. While he dutifully spent hours peering at Mars through the Clark telescope and sketching details into a logbook, he is most remembered for his controversial theories about intelligent life.

In some ways, Lowell can be compared to 19th-century naturalist T.H. Huxley, who did not propose the theory of evolution but became one of its strongest and most vocal supporters. Likewise, Percival Lowell was not the first to see the supposed canals on Mars or even the first to suggest their existence as evidence of intelligent life there, but he became the most outspoken advocate of these ideas.

Lowell developed a consciousness about life on Mars that delightfully impacted literature, inspiring writers such as H.G. Wells to craft popular books themed around Martian life.

Today, scientists know that the canals do not exist, and in fact, no definitive proof of any life on Mars—let alone intelligent forms—has been detected. Yet Lowell's compelling ideas remain important for historical reasons. His Martian research also set the stage for future studies at the observatory.

One of Lowell's contemporaries, E.C. Slipher, developed into a leading Martian expert. He used the Clark telescope for most of his research but also traveled to South Africa for three Mars-observing expeditions.

Slipher continued studying Mars up until his death in 1964, but by this time other astronomers at the observatory were carrying out Mars research. Leonard Martin, for instance, worked on several Mars projects during his three decades at Lowell. His observations of Mars were part of the International Planetary Patrol—a global network of observatories photographing many of the planets—and later was involved in projects using images captured with the *Viking* spacecraft and Hubble Space Telescope.

All in all, any conversation dealing with the history of Martian studies inevitably includes some mention of research carried out at Lowell Observatory.

In 1877, Italian astronomer Giovanni Schiaparelli (1835–1919) observed Mars during a particularly favorable approach to Earth. In the same year that American astronomer Asaph Hall discovered Mars's two moons, Phobos and Deimos, Schiaparelli detected a network of linear features he called *canali*, meaning channels. This discovery later helped inspire Percival Lowell to found his observatory to study what became known simply as canals, believing they were built by intelligent beings.

One of Percival Lowell's strongest supporters regarding life on Mars was zoologist/ Orientalist Edward Morse, shown in this 1905 photograph behind a table while Lowell sits nearby. In 1906, Morse wrote the book *Mars and Its Mystery* and dedicated it to Lowell: "To Percival Lowell, who has by his energy and scientific spirit established a new standard for the study of Mars, this book is affectionately inscribed."

In 1892, French astronomer Camille Flammarion wrote a now classic book about Mars, *la Planète Mars et ses conditions d'habitibilité*. It was a compendium of literature about Mars from the past several centuries up to that year and caught the attention of Lowell. Reading about Schiaparelli's *canali* in the book prompted Lowell to start studying Mars. These drawings of Mars by Flammarion were printed in a later volume of his book.

Lowell recorded details of his Mars observations in notebooks. Shown here is the first entry for the Clark telescope, based on observations he and Andrew Douglass made on July 23, 1896. Of particular interest is the amount and diversity of color Lowell detected: dark greens, yellows, and even a deep red (rosebud).

Above, the image to the left depicts one of Lowell's Martian drawings showing various dark patches, a polar ice cap, and the network of canals (not to be confused with the cartographic grid overlaying the image). Lowell believed the canals were stretches of vegetation growing along artificial waterways built by intelligent life. The image to the right is a photograph of the same region, likely taken by E.C. Slipher.

Based on the drawings of Martian details as recorded in his notebooks, Lowell created composite globes of Mars for most of its oppositions starting in 1895 and continuing for the next 20 years. They captured Lowell's vision of the canal system and associated features, and other surface characteristics, such as dark markings and polar ice caps.

Alfred Russel Wallace (1823–1913), pictured here, was a British naturalist best known for formulating a theory of evolution independent of Charles Darwin's. In 1907, he wrote the book *Is Mars Habitable?*. Incorporating his expertise on the development of life, Wallace refuted Percival Lowell's claims of Martian life as explained in Lowell's 1906 book *Mars and Its Canals*.

After Lowell died in 1916, future generations of astronomers at his observatory carried on the tradition of Martian research, most of them using the Clark telescope. One was Clyde Tombaugh (1906–1997), who would probably be more remembered for his Mars work today if it had not been overshadowed by his celebrated discovery of Pluto in 1930.

During the 1939, 1954, and 1956 Martian oppositions, E.C. Slipher organized expeditions to South Africa so he could observe the red planet from the Southern Hemisphere. He carried out most of this research at the Lamont-Hussey Observatory, which housed a 27.5-inch refracting telescope, shown here being operated by Slipher. This instrument, owned by the University of Michigan, was the largest refractor in the Southern Hemisphere at the time.

The Lamont-Hussey Observatory was located on Naval Hill in the Franklin Game Reserve at Bloemfontein, South Africa. Wildlife such as this herd of blesbok was a common sight around the telescope dome. The facility was located at an elevation of 4,890 feet and only 12 miles southwest of Harvard's Boyden Station, another astronomical observatory, which had an instrument shop available for Slipher's use.

Slipher captured this image of the dome during one of his 1950s visits. Its appearance changed very little during the observatory's lifetime (1928–1974). When the facility closed, the telescope's optics were sent to the University of Michigan and the tube and mount were stored in South Africa, but the dome remained standing, a stark monument to past research. It was eventually renovated and now houses a planetarium.

The Lamont-Hussey Telescope (shown here with E.C. Slipher in the 1950s) featured a 27.5-inch objective lens and a focal length of 40 feet. The instrument was used primarily to study double stars but also served some other projects, including Slipher's Mars studies. His colleagues at Lowell built various instruments for this research, including cameras and filters.

During his Martian research in South Africa, Slipher made both visual and photographic observations of the planet. For the visual ones, he looked through the telescope's eyepiece and carefully sketched in details, in the same manner as Percival Lowell and other astronomers from earlier eras. In these 1939 drawings, Slipher includes many of the supposed canals. Today, astronomers know these were illusory and not real Martian features.

To capture photographs of Mars, Slipher used specially designed four-inch-diameter brass cameras that he mounted to the telescope. In this photograph from the 1950s, Slipher (right) and an unidentified assistant load a glass-plate negative into the camera's plate holder. The glass plate is emulsified, recording the image in the same way as film did in later years. The plate holder is connected to the telescope via a long tube.

Slipher took thousands of images of Mars, such as this one from 1939, during his three observing expeditions to South Africa; in 1956 alone, he amassed 37,000. During his 1939 observing run, he captured one of the earliest—if not the first—color image of Mars. He also discovered several atmospheric features and measured the advance and retreat of the Martian polar ice caps.

During Slipher's 1956 Mars observations in South Africa, he was joined by a crew that used television equipment (shown here) to gather images. Technicians utilized an early type of vacuum tube called an image orthicon tube in the hopes of obtaining exceptional images. However, Slipher found the results disappointing, with images displaying a lower-quality definition than those captured by traditional photography methods.

By the mid-1950s, E.C. Slipher was one of the world's leading experts on Mars. In 1956, representatives from Walt Disney Studios targeted him to appear in the television special *Mars and Beyond*, which also featured rocket scientist Wernher von Braun. A film crew from Disney came to Lowell Observatory to capture footage. While there, producer/director Ward Kimball's wife, Betty, drew this sketch in the observatory's guest book.

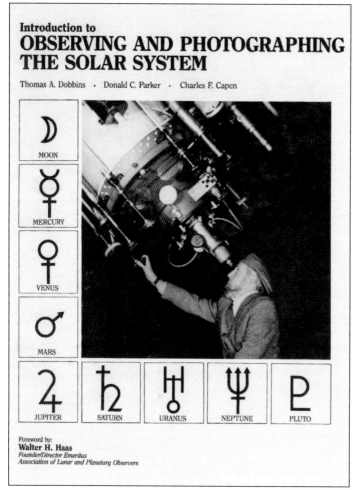

Charles "Chick" Capen (1926–1986) was a planetary astronomer primarily interested in Mars. He studied under Pluto discoverer and former Lowell observer Clyde Tombaugh at New Mexico State University and worked at Lowell from 1969 to 1983, carrying out planetary research. He also gave public tours, posing as Percival Lowell at the Clark telescope, as shown on this cover of a book he coauthored.

Leonard Martin (1930–1997) was a cartographer and astronomer who worked at Lowell Observatory from 1963 through his retirement in the mid-1990s, specializing on Martian studies. A poster of this 1988 image of Martin at the Clark telescope was featured on the first season of the television show *The Big Bang Theory*, displayed on the living room wall of characters Sheldon Cooper and Leonard Hofstadter. (© Roger Ressmeyer/CORBIS.)

For much of his career at Lowell, Leonard Martin studied the dust storms of Mars for the International Planetary Patrol, a global network of planetary observers organized and managed by Lowell Observatory. His research on storms, such as this group from 1973, was critical to understanding the variability of the Martian atmosphere.

1973 MAJOR STORM RED LIGHT

PRE STORM
Oct. 9

DAY 1
Oct. 13

DAY 2
Oct. 14

DAY 4
Oct. 16

DAY 6
Oct. 18

DAY 8
Oct. 20

DAY 16
Oct. 28

DAY 28
Nov. 10

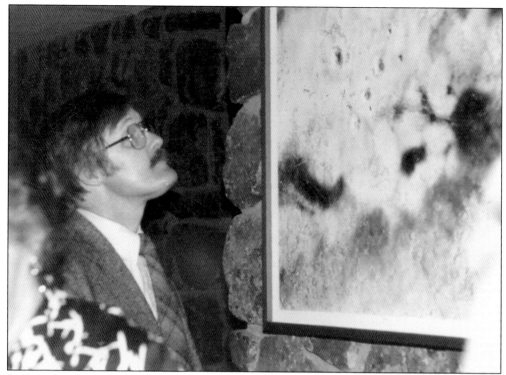

Jay Inge (1943–2014) was a cartographer who created moon and Mars maps. He came to Lowell in 1965 to map the moon in support of the Apollo program. He later moved to Washington, DC, to work for *National Geographic* but returned to Flagstaff after two years, going back to Lowell and then the US Geological Survey. In this photograph, Inge examines one of his masterpieces, a 1:12.3 million–scale map of Mars.

This image shows a detailed section of Inge's Mars map. He derived the albedo features from Earth-based observations by the International Planetary Patrol in 1969 and 1971. Inge based the topographic features on data from *Mariner 9*, launched in 1971, the first spacecraft to orbit another planet.

Five

PLANET X AND PLUTO

The most famous discovery at Lowell is that of Pluto in 1930, culminating a 25-year three-par search. The first, which Percival Lowell called the "Invariable Plane Search," was carried on from 1905 to 1909. Lowell believed a planet existed beyond Neptune and commenced a two-pronged pursuit. First, he mathematically calculated potential locations of the planet based on apparent irregular movements (perturbations) of Uranus. He then directed his staff to photograph the targeted areas of sky.

When the Clark telescope proved inadequate for the photographic effort, Lowell acquired a new five-inch instrument. Lowell was secretive about this first search effort and involved few staff members.

In 1910, a former Lowell colleague-turned-rival, William Pickering, began his own search for a new planet. This prompted Lowell to ratchet up his effort; he was now in a race because he wanted to be the one to discover what he now openly called Planet X. He redoubled his mathematical efforts and borrowed a nine-inch telescope from Sproul University, a great improvement over the five-inch Brashear.

With new calculations and improved equipment, Lowell was able to estimate the location of Planet X but died (in 1916) before he was able to carry out a photographic search in the appropriate area of the sky.

The observatory's search for Planet X temporarily ended with Lowell's death, but in April 1927, Roger Lowell Putnam, Percival's nephew, became the observatory's sole trustee and made the search for Planet X a top priority.

Percival's brother Abbott Lawrence Lowell donated money to build a new search telescope, and the observatory hired 23-year-old farmer and amateur astronomer Clyde Tombaugh to help with the search. The telescope was ideal for the project, and Tombaugh proved to have the patience and attention to detail necessary for the work.

Tombaugh discovered Pluto on February 18, 1930, less than a year after he began working at the observatory. The announcement of the discovery was made on what would have been Percival Lowell's 75th birthday, March 13, 1930. Within two months, the new body had a name, Pluto, and it has remained a focus of observatory research since.

During Percival Lowell's earliest photographic searches for a new planet, starting in 1905, Lowell and his assistants initially tried using the 24-inch Clark telescope but found its slow speed and small field of view inadequate for the search. A wide-angle instrument was needed, and the observatory tested several over the ensuing years, including a five-inch instrument made by the Pittsburgh instrument maker John Brashear.

After early results with the five-inch instrument looked promising, Lowell bought it from Brashear for $350. The instrument is mounted here on top of the six-inch refractor Douglass had used during his site-testing expedition in 1894. To fund operations for this and other telescopes during the early planet search, Lowell created the Lawrence Fellowship, a research program for Indiana University astronomy students that lasted from 1905 to 1907.

During the second stage of Lowell's planet search, spanning 1910 to 1916, he hired several "computers" to help with calculating the orbital characteristics of his predicted planet. These computers were people, specializing in reducing mountains of astronomical data. Lowell's head computer was Elizabeth Langdon Williams (1882–1981), shown here, a graduate of MIT who later married observatory Mars researcher George Hamilton (1884–1935).

Lowell's computers used the best calculating devices of their time. Here, an unidentified computer operates a Millionaire calculating machine with his left hand. The Millionaire was a mechanical calculator used to solve problems of addition, subtraction, multiplication, and division. On the table in the foreground is a Thacher's Calculating Instrument. This glorified slide rule featured a folded scale 60 inches in length.

In late 1913, Lowell wrote a letter to the director of Swarthmore College's Sproul Observatory, John Miller, asking to borrow a nine-inch telescope to continue the search for Planet X. Miller complied, and by the following spring, Lowell's staff was using the instrument regularly to photograph the sky. It was housed in this small wooden structure. This dome no longer stands, but remnants of the cement pier remain.

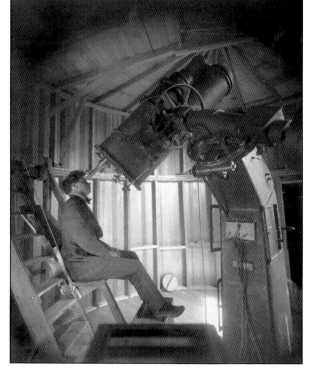

Computer-turned-observer Thomas Gill took many photographic plates using the nine-inch Sproul telescope. After Clyde Tombaugh discovered Pluto in 1930, Lowell staff reexamined Gill's plates and found that he had photographed Pluto on March 19 and April 17, 1915. The images were faint but nevertheless significant, as their positions were useful for determining Pluto's orbit.

After 10 years of trying to determine the position of Planet X mathematically, Lowell believed he had arrived at a solution. He published his conclusions in this 1915 publication, *Memoir on a Trans-Neptunian Planet*. Before his staff could search the appropriate areas of the sky, Lowell died (on November 12, 1916). With Lowell's death, the search for Planet X ended—temporarily, as it turns out.

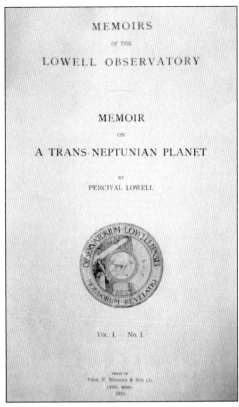

MEMOIRS

OF THE

LOWELL OBSERVATORY

MEMOIR

ON

A TRANS-NEPTUNIAN PLANET

BY

PERCIVAL LOWELL

VOL. I. — No. 1.

PRESS OF
THOS. P. NICHOLS & SON CO.
LYNN, MASS.
1915

In 1927, newly minted sole trustee Roger Putnam decided to resurrect Lowell's search for Planet X. Working with director V.M. Slipher, he procured funds from Percival's brother Abbott Lawrence Lowell to build a new facility designed specifically to search for the planet. Staff handyman Ramon Vielma (likely the person in this 1928 photograph) constructed the walls of the new structure, which would house a 13-inch telescope.

The dome consisted of two floors. A stationary circular wall comprised the lower level. It was constructed of a smooth cement base topped with chunks of weathered basalt known locally as Malpais rock. This is a common building material in northern Arizona, and it is used on many other structures at Lowell Observatory. Vielma and helpers collected this rock from the surrounding mesa.

The telescope pier was firmly embedded underground and extended up to the second floor, where the telescope was mounted. Without access to a hydraulic crane, workers rigged a double-beamed mechanical device using an array of ropes and pulleys to lift the heavy components of the mount and telescope to the upper levels of the dome.

A circle of metal wheels was attached to the top of the wall. On top of these wheels sat a metal ring, which connected to the dome. The entire assembly then rotated on top of the wheels. The ring (part of it shown here) and other metal components of the dome were built from wooden patterns constructed primarily by Lowell pattern maker Edward Mills (1866–1958).

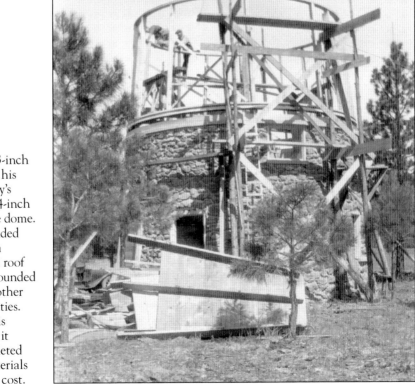

Stanley Sykes designed the 13-inch dome based on his brother Godfrey's design of the 24-inch Clark telescope dome. This plan included incorporating a slightly tapered roof rather than a rounded one typical of other observing facilities. Sykes chose this design because it could be completed using local materials at a reasonable cost.

Sykes and his team of helpers shaped the dome with a framework of wooden beams and then covered those with wooden slats. They then topped this with a layer of sheet metal to protect the structure from rain. They finished by painting the dome white—a typical practice with telescope domes—to reflect sunlight, helpful for reducing heat buildup during the day.

The 13-inch telescope is technically known as an astrograph, a telescope designed specifically to take images. Instead of making visual observations by peering through an eyepiece, the observer captured images on photographic glass plates. The 13-inch had a focal length of 66.5 inches and held 14-by-17-inch plates. The instrument's three-element lens arrived at Lowell on February 11, 1929, and staff installed it over the next several days.

As telescope construction wound down, observatory director V.M. Slipher hired Clyde Tombaugh to help with the planet search. Tombaugh was a 23-year-old farmer and amateur astronomer born in Illinois but living in Kansas since high school. He had built several of his own telescopes, including one out of parts from discarded farm machinery. Within months of his hire at Lowell, he was performing most aspects of the search.

On clear evenings, Tombaugh loaded the 13-inch telescope with a glass plate and then photographed a specific area of the sky. After about one hour, he replaced the exposed plate with a fresh one to image another part of the sky. He usually repeated this process several times each night. Days later, he would rephotograph those areas of the sky.

Tombaugh carefully recorded his efforts in a logbook, noting details ranging from the area of sky photographed to weather conditions. This page from Tombaugh's logbook documents information about a plate he took near the star Delta Geminorum on January 21, 1930. He found the images to be fuzzy. He tried again on the 23rd, made a clear plate, and then captured a second good one on the 29th.

This blink comparator machine, built by the Zeiss optical company, allowed Tombaugh to carefully examine the paired plates. Over several days, relatively nearby celestial objects such as planets could be seen moving against the stationary stars. On February 18, 1930, Tombaugh was examining the January 23 and 29 pair of plates when he discovered what appeared to be a planet.

Observatory staff studied the new body for weeks. By the middle of May, they felt confident this was, in fact, a planet and set the date of March 13 to share the discovery with the world. This would have been Percival Lowell's 75th birthday; announcing the discovery on this day paid tribute to the man who began the search. This card served as the official announcement to the scientific community.

As news of the discovery spread, the observatory received more than 250 letters and telegrams from around the world with suggestions for a name. One of these was sent by British astronomy professor Herbert Turner (1861–1930) on behalf of an 11-year-old girl from Oxford, Venetia Burney (1918–2009), shown here. Burney would grow up to became an accountant and later a teacher.

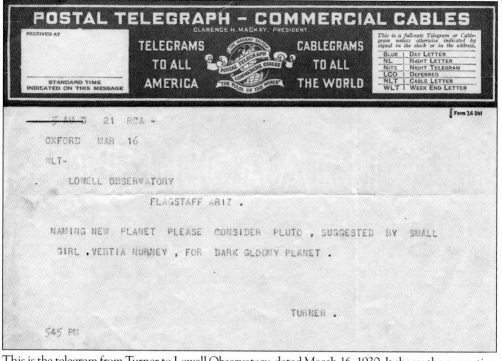

5 AU D 21 RCA –

OXFORD MAR 16

WLT-

. LOWELL OBSERVATORY

FLAGSTAFF ARIZ .

NAMING NEW PLANET PLEASE CONSIDER PLUTO , SUGGESTED BY SMALL

GIRL .VEBTIA NURNEY , FOR DARK GLOOMY PLANET .

TURNER .

545 PM

This is the telegram from Turner to Lowell Observatory, dated March 16, 1930. It shares the suggestion of Venetia Burney, whose name is grossly misspelled here. Burney was familiar with mythological characters from her school studies. She liked Pluto as a name for the planet because in Roman mythology Pluto was the god of the underworld, appropriate for a "dark, gloomy planet."

> Finally the orbit is no sufficient ground upon which to venture a decision as to the nature of such an object. Here is suggested an obvious analogy between the Sun's increased family of planets and the satellite system of Jupiter whose newer satellites have orbits at considerable variance with these of the older satellites, just as the orbit of Planet X differs from those of its older brothers. It is pertinent to draw attention to the fact that Planet X has like the older planets direct motion about the Sun.
>
> This then appears to be a Trans-Neptunian, non-cometary, non-asteroidal body that fits substantially Lowell's predicted longitude, inclination and distance for his Planet X. Lowell considered his predicted data as only approximate, and a one to one correspondence between forecast and find would not be expected by those familiar with the problem. As he himself said in his Trans-Neptunian Planet Memoir: "Analytics thought to promise the precision of a rifle and finds it must rely upon the promiscuity of a shot gun." This remarkable Trans-Neptunian planetary body has been found as a direct result of Lowell's work, planning and convictions and there appears present justification for referring to it as his Planet X.
>
> It seems time now that this body should be given a name of its own. Many names have been suggested and among them Minerva and Pluto have been very popular. But, as Minerva has long been used for one of the asteroids it is really not available for this object. However, Pluto seems very appropriate and we are proposing to the American Astronomical Society and to the Royal Astronomical Society, that this name be given it. As far as we know Pluto was first suggested by Miss Venetia Burney, aged 11, of Oxford, England.† As a fitting symbol to go with the name we have suggested ♇, easily remembered because the first two letters of the name and not to be confused with the symbols of the other planets.
>
> V. M. SLIPHER.
>
> Flagstaff, Arizona
> May 1, 1930.
>
> † Kindly cabled by Prof. H. H. Turner.

Burney was not the only person to suggest Pluto for a name, but she was considered the first. In this *Lowell Observatory Circular* from May 1, 1930, V.M. Slipher announced that the observatory was proposing Pluto as the new planet's name. All planets in the solar system have a symbol, and Slipher followed suit by suggesting one for Pluto, a combination of its first two letters (and also Percival Lowell's initials).

Six

WE CHOOSE TO
GO TO THE MOON

In a defining moment of the 20th century, astronauts Neil Armstrong and Buzz Aldrin broke the bonds of Earth and stepped onto the moon on July 20, 1969. This singular achievement was accomplished due to the efforts of hundreds of thousands of people and organizations.

Lowell Observatory contributed in multiple ways, highlighted by an the creation of maps of the lunar surface. These were used in a variety of capacities, including the determination of landing sites for moon-bound astronauts.

In 1960, the Aeronautical Chart and Information Center (ACIC), a branch of the US Air Force, began a project to map the moon. While lunar photographs were available for this effort, planners realized they could achieve a much higher level of accuracy by comparing these images to live observations through a telescope.

A sequence of correspondence between leaders of ACIC and several observatories around the country laid a path to Lowell. The Clark telescope turned out to be an ideal instrument for the work and was not in regular use at the time, so in 1961 the ACIC contracted with Lowell to use the Clark and later, a 20-inch telescope acquired in 1964. The ACIC also rented office space at Lowell until the program ended in 1969.

Related to this work, astronauts visited Lowell in 1963 to learn how lunar features are depicted on maps. This was part of a whirlwind day of training in the Flagstaff area. In the morning, they visited Meteor Crater to see an impact crater resembling what they would see on the moon.

The astronauts later toured Lowell's ACIC facility to learn about the mapping program, after which they divided up into three groups to view the moon through telescopes. Some used the 24-inch reflecting telescope at Arizona State College (today known as Northern Arizona University), while others gazed through the US Naval Observatory's 40-inch reflector, both just a few miles from Lowell. The rest of the group used Lowell's Clark telescope, the instrument used to create the moon maps.

The ACIC opened an office at Lowell Observatory on September 1, 1961. Staff included site manager William Cannell (1926–2006), observer James Greenacre (1914–1994), and illustrator Patricia Bridges (b. 1933). Cannell and Greenacre did most of the observing at the Clark telescope while Bridges created the drawings. She compared data from their observations with lunar images to draw details using an airbrush (shown here). (Patricia Bridges.)

ACIC's successful program at Lowell expanded, and by 1965, staff size had ballooned to more than one dozen. In this 1965 photograph, staff pose in front of the recently enlarged ACIC office. From left to right are William Cannell, Sharon Gregory, Leonard Martin, Louise Riley, Fred Dungan, Barbara Vigil, Bob Maulfair, Tom Dungan, Cliff Snyder, James Greenacre, Gail Gibbons, Terry McCann, Bruce Faure, Pat Bridges, and Jim Jennings. (Patricia Bridges.)

Observers such as William Cannell (right) spent hours viewing the moon through the Clark telescope, taking notes on various lunar features. Details were especially clear during periods of good seeing conditions. When these occurred, the observer called down to the ACIC office, encouraging an illustrator (in this image, Patricia Bridges) to hurry to the telescope and witness the highly resolved features firsthand. E.C. Slipher stands at left.

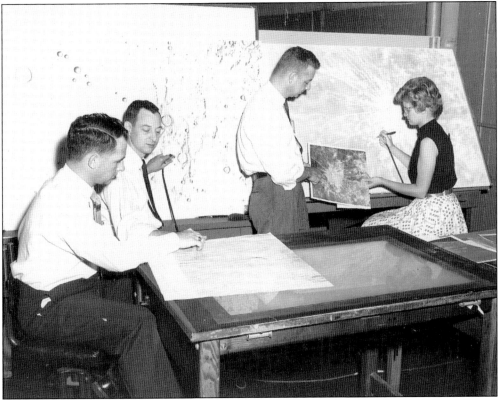

ACIC's observers, photographers, and illustrators worked together to create a variety of lunar maps and charts that displayed physical characteristics of the lunar surface. In this photograph, staff examine one of these maps while Patricia Bridges (far right) and an unidentified person look at a close-up image of the moon. (Patricia Bridges.)

On October 29, 1963, James Greenacre (left) and Edward Barr were examining the Aristarchus region of the moon through the Clark telescope when they detected strange colorings of bright red, orange, and pink colors. Other observers had experienced similar "transient lunar phenomena" through the years. These unusual features seemed to indicate some sort of activity, perhaps volcanic, on the moon, but their true nature has never been proven.

In this c. 1962 photograph, Patricia Bridges works in her office at Lowell's ACIC building. Drawings and close-up images of the moon sit on her tables. Behind her is an air tank, connected to the airbrush she used for sketching details as she created the lunar maps and charts. (Patricia Bridges.)

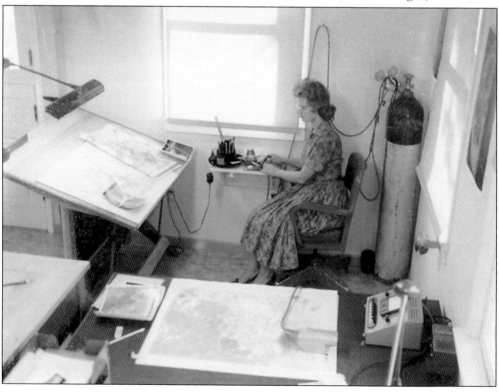

Here is a close-up of Patricia Bridges working on one of her maps. The impact crater Copernicus is clearly visible toward the middle of her drawing. Several smaller craters can also be seen surrounding Copernicus. The array of shadowed sinuous lines represents topographic features such as valleys and ridges of rock. (Patricia Bridges.)

Detailed Lunar Charts Will Guide Apollo Astronauts THE SUN, Flagstaff, Ariz. Wed., Jan. 30, 1963

Air Force Maps Moon From Flagstaff

By WILLIAM HOYT
(First of Two Articles)

In a neat, well-lighted office on Mars Hill hangs a bluish-green tinted chart of the Copernicus area of the moon.

On the chart, someone with a sense of humor and a sense of pride has pinned a small, printed sign which reads: "Made on the Moon by the U.S. Air Force."

The sign, of course, is not literally true — yet. But it will be someday.

Until that day, the Aeronautical Chart and Information Center of the U.S. Air Force is doing the next best thing. It is making the finest, most detailed, most accurate maps of the moon extant — from Flagstaff.

For more than a year now, four members of the ACIC's Lunar Observation office have been working quietly and steadily at Lowell Observatory here, mapping the visible surface of the moon in grid sections, each of which covers a lunar area roughly equivalent to the size of Arizona.

When they have finished with the visible surface, several years hence, they expect lunar satellites will be orbiting the moon and furnishing them with enough information to map the moon's backside, perpetually turned away from the earth. When that chore is completed, they plan to take a crack at turning out an Astronaut's road map of the planet Mars, earth's nearest neighbor in the solar system.

"It doesn't look like we'll run out of work, or things to map, for many years to come," soft-spoken William Cannell, head of the ACIC's office here concedes. "After we've made the maps, we'll keep working to make them better."

A primary purpose of the lunar mapping operation here, of course, is to provide America's Apollo Astronauts with the best possible

not be "President Kennedy Crater" or "Governor Fannin Crater" or even "Cannell Crater." The ACIC is bound to follow the IAU's nomenclature rules and consequently new features are given designations which relate them to already-named features on the moon. A small crater in the immediate area around the crater of Copernicus, for instance, would be given the efficient, but unromantic handle of "Copernicus A" and so on down the alphabet.
(Tomorrow: How the Moon is Mapped)

On January 30, 1963, Flagstaff's local newspaper, the *Coconino Sun* (now known as the *Arizona Daily Sun*) featured a story about the ACIC's moon-mapping program. It featured the finished version of Patricia Bridges' map that centered on the crater Copernicus. Grid lines, feature names, and topographic lines are all visible here. (Patricia Bridges.)

The ACIC office at Lowell generated more than 100 lunar maps and charts on scales ranging from 1:500 to 1:8.5 million. The map shown here represents a relatively flat stretch of the lunar surface. The lack of topography made this an ideal target for landing the first manned spacecraft, *Apollo* 11, on the moon. This mission's actual landing site is indicated by the left arrow.

As the ACIC program expanded, the moon mappers realized an additional telescope would allow them to increase their rate of map production. To accommodate this need, Lowell Observatory purchased a 20-inch refracting telescope from amateur astronomer Ben Morgan of Texas in 1963. The instrument came with a dome, shown here in segments at the corner of Santa Fe Avenue and Toltec Street in Flagstaff, one-half mile from the observatory.

On December 4, 1963, workers used a crane to lift the dome segments on top of the stationary walls at the facility's new home at Lowell Observatory. Staff spent the next several months finishing construction, and on April 15, 1964, officials from NASA, the ACIC, and Lowell dedicated the new facility.

Once the 20-inch telescope was installed, its eyepiece was very high off the floor. To reach it, staff installed a hydraulically operated elevator floor, which would lift the observer up to 12 feet to reach the eyepiece. Years after the ACIC office closed, Lowell engineers replaced the 20-inch telescope with an 18-inch astrograph to be used in predicting stellar occultations.

Jay Inge started working at Lowell's ACIC office in 1965; at about the same time, Patricia Bridges left to raise her children. With her departure, Inge quickly assumed the role of lead moon mapper. Between 1968 and 1969, he spearheaded the effort to create a lunar globe for NASA. He is shown here (in the foreground) with Paul Rodriguez working on the "gore" drawings that were later assembled to form the globe.

Inge and his team finished the moon globe in May 1969. It was the final product of the ACIC office before it closed. The globe measured 16 inches in diameter and captured 99 percent of the lunar surface. Surface features were drawn with an assumed eastern light source, approximating the conditions during a morning landing by spacecraft. A copy of the globe was given to then president Richard Nixon.

On January 16, 1963, NASA Astronaut Group 2 trained for a day in Flagstaff. During the morning and afternoon, they studied geology at Meteor and Sunset Craters, good analogs for similar features on the moon. In the evening, they ate dinner at Lowell Observatory in the new home of Lowell director John Hall. While here, they signed the observatory's guest register book. Pictured here is Jim Lovell. (JSC History Collection.)

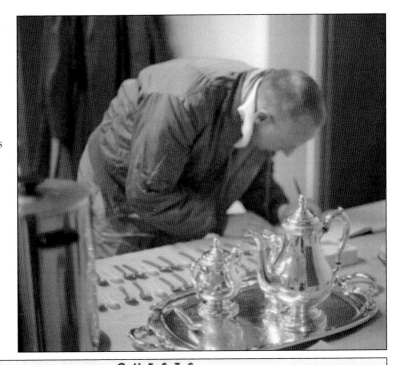

GUESTS

DATE	NAME	RESIDENCE
8-29	*[signature]*	*[illegible]* Yahly PCC. Astronomy Dept. The University *[illegible]* 13 England.
12 Sep 62	David Blake	Lick Observatory, Mt. Hamilton, California
- Ap. 62	Gerald E. Kron	
24 Sep 62	Ramakrishnan V. Karandikar	Nizamiah Observatory, Hyderabad, India
26 Sep 62	齊藤國治 [Kuniji SAITO]	Tokyo Astronom. Obs. Mitaka, Tokyo
Oct 9,62	Joseph O. Fox	San Juan, Puerto Rico
Oct 9,62	Theodore Dunham Jr.	Mt. Stromlo Observatory, Canberra, Australia
Oct. 17,62	L. DELBOUILLE	INSTITUT D'ASTROPHYSIQUE, LIÈGE, BELGIUM
Oct 17, 62	G. Roland	"
Oct 30, 62	Gordon C. Augason	Ames Research Center, Moffett Field, Cali.
—"—	Charles P. Lovett	"
Nov. 2, 62	Konrad Rudnicki	Warsaw University Observatory (Poland)
Nov 4, 1962	Gordon W. Wares	AF Cambridge Research Labs, Bedford, Mass.
16 Jan 63	James A. Lovell	Manned Spacecraft Center, Houston, Texas
16 Jan 63	James A. McDivitt	Manned Spacecraft Center, Houston, Texas

This guest register page sports the signatures of Jim Lovell and Jim McDivitt. The other visiting astronauts, plus NASA officials, local geologists, and several special guests, signed the book on other pages. This page also shows, unrelated to the astronaut visit, signatures of other visitors, including astronomers Gerald Kron and Theodore Dunham Jr.

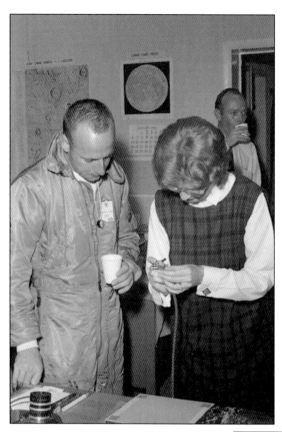

After dinner at John Hall's house, the astronauts walked over to the ACIC building to learn about the mapping program. This allowed them to see how the craters and other geological features they had explored earlier in the day were depicted on maps. Here, Patricia Bridges demonstrates the technique for airbrushing lunar details to astronaut Charles "Pete" Conrad. (JSC History Collection.)

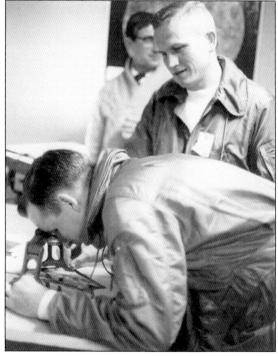

Astronaut Ed White looks through a pocket stereoscope to examine lunar features while fellow astronaut Frank Borman looks on. Two years later, White would become the first American to walk in space, but two years after that he tragically died during a launch-pad fire. Borman's career as an astronaut was capped when, in 1968, he commanded the first manned mission to circle the moon. (JSC History Collection.)

Astronaut John Young studies images of the moon used to create the lunar maps. Young was one of America's most prolific astronauts, flying in space six times spanning three manned spaceflight programs: Gemini, Apollo, and the space shuttle. He worked at NASA for 42 years before finally retiring in 2004 at the age of 74. (JSC History Collection.)

The astronauts also examined maps of Mars to learn how to interpret geological features. Here, Lowell astronomer and Mars expert E.C. Slipher uses a pen to point out features on a Martian map. Looking on are astronauts Tom Stafford (seated) and Neil Armstrong (left), who later would become the first person to walk on the moon. (JSC History Collection.)

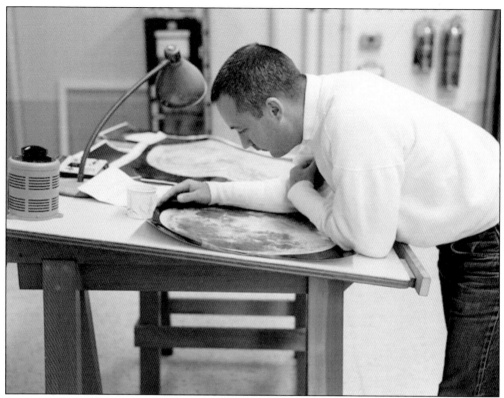

Astronaut Jim McDivitt scrutinizes a large photograph of the moon. McDivitt later commanded the flight that saw White walk in space. Typical of the early astronauts, McDivitt's educational background focused on engineering, not science, and he served as both a combat pilot (during the Korean War) and test pilot. (JSC History Collection.)

May our contributions to your work be as helpful as your contributions to ours

Neil Armstrong

1-16-63

E.C. Slipher's 10-year-old grandson Edwin was on hand for the 1963 astronaut visit to Lowell. E.C. had bought Edwin an autograph book, which he passed around for the astronauts to sign. Here is the page autographed by Neil Armstrong, with an inspirational message followed by Armstrong's distinct signature. Nearly 50 years later, Armstrong returned to Lowell to help dedicate the observatory's new Discovery Channel telescope.

Seven

SKY WATCHERS AND THEIR DISCOVERIES

Percival Lowell's controversial Mars research, Clyde Tombaugh's discovery of Pluto, and the ACIC's moon-mapping efforts are three of Lowell Observatory's most celebrated contributions to space exploration. Yet these represent just the tip of the iceberg of overall research carried out in the hallowed halls of Mars Hill.

Perhaps the most far-reaching discovery was V.M. Slipher's detection of the radial velocity of spiral nebulae. These were faint, fuzzy patches in the sky; using the principle of Doppler shift, Slipher measured their relative movement—in relation to his observing position on Earth—and found they were moving at incredible speeds, mostly away from Earth.

Using a spectrograph attached to the Clark telescope, Slipher began making these observations in 1912 and continued for years afterward. His measurements were critical to deciphering the vastness and antiquity of the universe and greatly influenced cosmologist Edwin Hubble in formulating his theory of the expanding universe. As a result of this research, astronomers know today that the spiral nebulae are galaxies in their own right, distinct from the Milky Way.

Another important project was Henry Giclas's proper motion survey. Proper motion is, simplified, a star's apparent change in position over time. At Lowell, Clyde Tombaugh's search for Pluto, and later more planets, resulted in a photographic record of the majority of the sky from the Northern Hemisphere. From 1957 to 1971, Giclas led an effort to rephotograph the same areas of the sky. Staff then closely compared these images with Tombaugh's corresponding ones and measured the changes in position of select stars.

The proper motion photographs not only provided data for the survey, but also serve as a record of the night sky at a particular point in time, revealing galaxies, stars clusters, supernova, and other celestial features.

These and other research projects played a key role in establishing Lowell Observatory as a significant center of astronomical research, setting the stage for astronomers of today and tomorrow to continue the quest to unravel the mysteries of the universe.

Vesto Melvin "V.M" Slipher (1875–1969) began working at Lowell in 1901 and stayed for his entire career. In addition to his duties as an astronomer, he became director of the observatory upon Percival Lowell's death in 1916 and held that position until retiring in 1952. He is credited with measuring the rotational period of several planets, proving the existence of interstellar dust and gas, and measuring the recessional velocity of spiral nebulae.

Slipher made most of his important discoveries with this spectrograph, used in conjunction with the Clark telescope to measure spectra of planets, stars, and other celestial objects. Starting in 1912, he began taking spectra of distant objects then known as spiral nebulae (astronomers now know they are galaxies). These required prolonged exposure times, some up to several dozen hours spanning over many nights.

The first spiral nebula Slipher measured was Andromeda (shown here in an image likely captured by Robert Burnham with Lowell's 13-inch telescope). He determined it was speeding toward the Milky Way at a rate of 300 kilometers (186 miles) per second. As Slipher measured more spiral nebulae, he found most of them moving away but at still incredible speeds, some six times that of Andromeda.

In 1914, Slipher presented velocity measurements of 15 spiral nebulae at the 1914 meeting of the American Astronomical Society. The audience of astronomers, recognizing the significance of his results, gave him a standing ovation. In this photograph of meeting participants, Slipher stands in the second row from the top, second from left. Edwin Hubble, then a graduate student at the University of Chicago, stands in the first row, third from right.

Carl Lampland (1873–1951) studied astronomy at Indiana University, as did V.M. and E.C. Slipher. Like the Slipher brothers, he also spent his entire professional career at Lowell. He helped during the early stages of Percival Lowell's search for a ninth planet and later became an expert astrophotographer. His most significant work involved building thermocouples, which he used to measure the temperatures of planets.

Arthur Adel (1908–1994), standing here at Lowell's Clark telescope, studied mathematics and physics at the University of Michigan, earning his doctorate in 1933. He worked at Lowell Observatory for several years in the 1930s and early 1940s, specializing in the study of Earth's atmosphere. Some of his most significant contributions include the discoveries of atmospheric nitrous oxide, atmospheric heavy water vapor, and the 20-micron window in Earth's atmosphere.

For decades, Lowell scientists have studied the behavior and physical characteristics of comets, including Halley, shown in this classic image taken at Lowell in 1910. Carl Lampland mounted a wide-angle camera on top of the Clark telescope to capture this image. It shows the comet, planet Venus (large bright circle), Flagstaff city lights (parallel streaks at lower left), and a meteor (faint line angling through the comet's tail).

Since Percival Lowell's death in 1916, nine people have served as director. They have all been astronomers, continuing their research as administrative duties allowed. V.M. Slipher (right) occupied the position from 1916 to 1954 and Albert Wilson (left) succeeded him, serving from 1954 to 1957. Others include E.C. Slipher (1957–1958), John Hall (1958–1977), Arthur Hoag (1978–1986), Jay Gallagher (1986–1989), Robert Millis (1989–2009), Eileen Friel (2009–2010), and Jeffrey Hall (2010–present).

Henry Giclas (1910–2007), shown here at Lowell's 13-inch telescope, grew up in Flagstaff and spent a lot of time at the observatory throughout his childhood. He began working at Lowell in 1931 as an assistant and later became an astronomer. He is best known for leading the proper motion program at Lowell but also discovered a number of comets and asteroids.

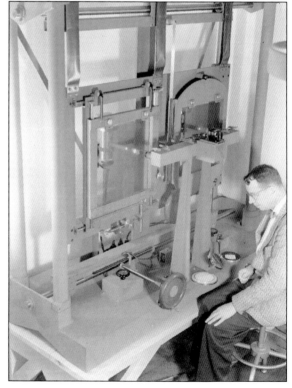

To precisely measure the positions of stars for the proper motion survey, Giclas acquired this blink comparator machine. It was a modernized version of the device Clyde Tombaugh used to discover Pluto. Staff examined photographic plates of the entire Northern Hemisphere and a third of the Southern Hemisphere, detecting more than 11,000 stars with significant proper motion. Additionally, staff also noted the positions of more than 1,500 asteroids.

The primary proper motion staff included Giclas, Norman Thomas (b. 1930), and Robert Burnham (1931–1993), shown here at the 13-inch telescope. When not carrying out his proper motion duties, Burnham spent most of his time working on a three-volume astronomy reference manual, the now-famous *Burnham's Celestial Handbook*. He organized this 2,138-page compendium by constellation and crammed it with images, scientific data, historical references, mythological stories, and general observations.

In 1965, Lowell opened the Planetary Research Center (PRC), a NASA-funded facility that would house the observatory's growing staff of planetary astronomers. Astronomer William Baum (1924–2012), pictured here, directed the research activities there, including those of the International Planetary Patrol. Established in 1969 and based at Lowell, this was a program involving several observatories around the world dedicated to regular and coordinated planetary observing.

The PRC housed staff, the observatory's library, and a collection of planetary images collected from a variety of observatories during the previous 60 years. Shown here at the dedication of the PRC in 1965 are, from left to right, William Burke (NASA), Urner Liddel (NASA), John Hall (Lowell Observatory), Gerard Kuiper (Lunar and Planetary Center), and Roger Putnam (Lowell Observatory).

Astronomer Vera Rubin (b. 1938), shown here with Lowell's Perkins telescope, spent most of her career at the Carnegie Institution of Washington. She used Lowell facilities for two important projects. In the 1960s, she and Carnegie instrument maker Kent Ford developed a highly sensitive image tube spectrograph on Lowell's 24-inch Morgan telescope. During the following decade, they used the instrument on several telescopes, including the Perkins, and discovered dark matter.

Robert Millis (b. 1941), who would direct observatory operations from 1989 to 2009, began working as an astronomer at Lowell in the 1960s. He spent his entire professional career at Lowell, studying planets, comets, Kuiper belt objects, and other solar system bodies. In this photograph from 1977, he joins colleagues Lawrence Wasserman (left) and Otto Franz (right) in examining a strip chart they used in codiscovering the rings of Uranus.

Clyde Tombaugh left the observatory in 1945 and spent most of his remaining career teaching astronomy at New Mexico State University. He returned to Lowell many times through the years, sometimes to use the facilities for research, other times to participate in special observatory ceremonies. Pictured here in 1989 are, from left to right, Patsy and Clyde Tombaugh, observatory director Jay Gallagher, and observatory supporters Ron and Loretta Morgan.

During his 19-year tenure as director, John Hall (1908–1991), far right, brought the observatory into the modern era with progressive ideas about funding and research. He oversaw the addition of the Perkins telescope, a planetary research center, and a new 42-inch telescope later named in his honor. In this 1980 photograph he is joined by, from left to right, Beverly and Bill Hoyt, Marge and Art Hoag, and his wife, Ruth.

William Graves Hoyt (1921–1985) was not a Lowell scientist but rather a journalist and research associate who wrote about the history of Lowell science. With two observatory-themed books, *Lowell and Mars* and *Planets X and Pluto*, plus a variety of magazine and newspaper articles, he helped preserve a considerable amount of the observatory's rich scientific heritage. Here he signs copies of *Planets X and Pluto* at a 1980 book-signing event.

Eight

INSTRUMENTS OF THE TRADE

The primary tool for astronomical research is the telescope, and Lowell Observatory astronomers have used quite a number of them through the years. Some of these, like the Clark and 13-inch, have been covered in earlier chapters. Others are sufficiently reviewed in this chapter with a single image. Two others, the 40-inch reflector and Perkins 69-inch, feature compelling stories best shared with a series of images.

In the observatory's early days, the majority of telescopes were located on Mars Hill, just west of downtown Flagstaff. Many of these still stand and serve as a reminder of the numerous astronomers who once toiled in these domes night after night, year after year, and whose coldness and loneliness were tempered by a desire to contribute to humanity's understanding of the universe.

Some of the Mars Hill telescopes are gone, but their domes remain. A review of these quickly reveals an interesting diversity of dome sizes and styles. The Clark and 13-inch domes, for instance, look like inverted buckets, with nearly flat roofs. The structure that houses a 21-inch reflecting telescope has a roof that completely rolls off, while the so-called "Jiffy Pop" dome is partially sunk in the ground.

Several facilities were established off-site for temporary use, like the field station that once sat on the San Francisco Peaks at an elevation exceeding 11,000 feet. Another example is V.M. Slipher's spectrograph rigged to a wooden telescope for observing a 1923 solar eclipse in Baja California. These are included as a reminder that some research involves travel to other locales where facilities do not exist; the observer has to take all the needed equipment, set it up for the observing event, and then disassemble and remove the equipment, usually leaving no permanent trace of the observatory's presence there.

When the Anderson Mesa dark-sky site was established in 1959, several telescopes were permanently moved to that site, located 12 miles southwest of Mars Hill. Two of these are discussed here for historical continuity, but the others are relatively new.

A discussion of instruments is not complete without mention of machinist/instrument maker Stanley Sykes (right). He first became associated with Lowell while helping his brother Godfrey build the Clark telescope dome in 1896. He soon was brought on as a full-time employee and, for decades, built and repaired telescopes and various instruments and the facilities in which they were housed. He is shown here with pattern maker Edward Mills (left).

In 1908, Percival Lowell contracted with the Alvan Clark and Sons firm—the same company that built the 24-inch refractor—to construct a 40-inch reflecting telescope for photographing planets. Dome construction began in June 1909, and Eli Giclas (father of future Lowell astronomer Henry) of the Arizona Lumber & Timber Company brought in a hoist for the work. In this photograph, he stands in the pit with a dog.

The instrument consisted of an open telescope tube installed on an English-type rectangular polar axis mount that measured 11 feet by eight feet. This image shows Carl Lundin Jr. (standing on the tube to the left), the Alvan Clark & Sons optician who made the telescope's mirror and came to Lowell to oversee telescope installation.

Percival Lowell directed that the facility housing the telescope be sunk into the ground six feet, with only the rotating portion above ground. He believed this would shield the reflector from wind and also help stabilize the temperature, thus reducing image deformation due to temperature-related changes. Years later, staff determined that sinking the dome did nothing to improve the image and, in fact, may have been counterproductive.

The dome consisted of a wooden frame covered by chicken wire and then canvas (also known as cotton duck, commonly used in making wagon covers and tents). When applied to the dome, the material was baggy, but tightened after the first good rain. This material did not stand up very well against the weather and had to be replaced every three or four years.

The finished dome was entered through a doorway that opened to a short set of downward-leading stairs. The use of canvas to cover the dome, as shown here, lasted until 1956, when staff replaced it with more sturdy aluminum sheets. This shiny material gave rise to the nickname "Jiffy Pop" dome after the popular popcorn product; it is also referred to as the Lampland Dome after Carl Lampland.

The telescope was the largest in Arizona for decades. Lampland was the chief operator for years, briefly using it for the Planet X search but mostly photographing nebulae and planets and measuring the temperatures of planets. Starting in 1948, Harold Johnson (1921–1980) and Henry Giclas used it to study planetary atmospheres and output variations of the sun, projects that continued with other astronomers and telescopes into the 21st century.

The 40-inch was one of several instruments made by Alvan Clark & Sons that the observatory operated. Others of note included the six-inch used by Douglass on the 1894 expedition, the 13-inch used for the discovery of Pluto, and the 24-inch. Representatives of the firm worked closely with Lowell staff on the installation and maintenance of these instruments. Here Carl Lundin Jr. makes adjustments on the 40-inch telescope.

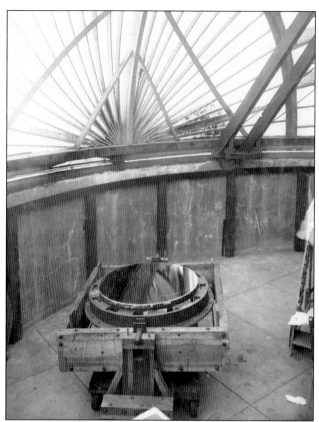

The mirror of the 40-inch telescope was seven inches thick and weighed 907 pounds. It actually had a diameter of 42 inches, but a portion was obscured when it was installed into its mounting ring, resulting in a usable surface of only 40 inches. In 1925, Stanley Sykes modified the ring, making the entire 42-inch surface usable.

In 1964, staff wanted to make the telescope more functional for spectrographic studies and polarization measurements. To do this, they decided to reconfigure the telescope's optical configuration to one known as Cassegrain, meaning a hole, through which light would pass, had to be drilled into the mirror. During this process, the mirror shattered, ending any hopes of reconfiguration.

Two years after the mirror shattered, the telescope was back in limited use when staff installed a 30-inch mirror in place of the broken one. The observatory also acquired a new 42-inch telescope (shown here) as a true replacement for the old one, mounting it at the Anderson Mesa dark-sky site. It was later named the Hall telescope in honor of director John Hall.

Throughout the years, Lowell astronomers have traveled around the world chasing eclipses, stellar occultations, and other short-lived astronomical phenomena. This involves shipping all necessary equipment to the observing site, setting it up for the event, and then returning it when finished. One such event was a 1923 solar eclipse in Baja California. Staff rigged Slipher's spectrograph to a large wooden telescope to gather solar spectra during the eclipse.

Some 50 yards west of Lampland's 40-inch dome, the observatory built a new roll-off roof structure in 1921. For years it housed this 15-inch telescope, built by Stanley Sykes. It consisted of an open box framework attached to a mount, as shown here. Stanley Sykes would use this same cross axis design when building the 13-inch telescope seven years later.

The roll-off roof structure consists of walls and a roof that rests on a wheeled track. To open, the roof rolls onto the framework to the left, leaving the telescope exposed to the entire sky. In 1953, a 21-inch close-tubed telescope replaced the 15-inch instrument. This new telescope, still in operation, has been used for long-term studies of solar variability and atmospheric changes in the outer planets.

Periodically from 1908 into the 1930s, Lowell operated a high-elevation field station on top of Doyle Peak (labeled on some maps as Schultz Peak) in Flagstaff's nearby San Francisco Peaks. Observations here included V.M. Slipher's search for water vapor on Mars and Cornell University's measurements of meteors. One of the telescopes used here was the 15-inch that had been housed in the roll-off-roof structure. Remnants of the station remain today.

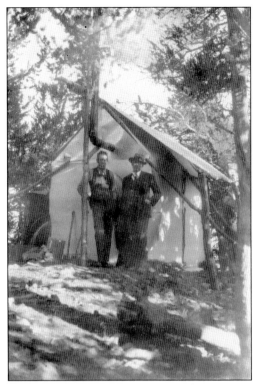

In 1960, Lowell Observatory partnered with Ohio Wesleyan University and Ohio State University to move their jointly operated 69-inch Perkins telescope to Flagstaff, where observing conditions were superior to those in Ohio. The telescope dates back to the 1920s, when it was built with funding from retired Ohio Wesleyan professor Hiram Perkins. It is pictured here on October 31, 1923, during construction at the J.W. Fecker Factory in Pittsburgh.

61 INCH PERKINS REFLECTOR, O. W. U. DELAWARE, OHIO THIRD LARGEST IN THE WORLD

The telescope would eventually hold a 69-inch mirror, but it would not be ready for years. In the meantime, technicians installed a 61-inch stand-in. The 69-inch was finally installed on December 14, 1931, making the telescope the third largest in the world. This vintage postcard shows the telescope before the 69-inch mirror was added.

PERKINS OBSERVATORY, OHIO WESLEYAN UNIVERSITY DELAWARE, OHIO

Another vintage postcard features the finished dome in Delaware, Ohio, 30 miles north of Columbus. While the telescope was later removed, the building has remained and today serves as a center for astronomy and space exploration. The 69-inch mirror, long-since retired from service and sent back to Ohio in the mid-1960s, was returned to the Perkins Observatory in 1999 and is now on public display.

In 1932, Perkins Observatory director Harlan Stetson created a quarterly magazine called the *Telescope*, featuring popular articles written by professional astronomers. In early issues, Stetson used a picture of his observatory on the front cover. In 1941, this magazine merged with another popular astronomy publication, the *Sky*, to form *Sky and Telescope* (first issue shown here), today one of the most popular magazines for amateur astronomers.

When the Perkins telescope was moved to Flagstaff in 1960, it had been surpassed in size by newer telescopes but was still the fifth largest in the United States. In 1965, observatory leaders decided to replace the 69-inch mirror with a new 72-inch one made out of Pyrex. This material is much less susceptible to warping due to temperature fluctuations, making it an ideal material for telescope lenses.

In 1962, the observatory built the "Chalet," a dual-purpose facility 100 yards northwest of the roll-off roof structure. One side of the new building (shown here in the foreground) housed the 24-inch Ronnie Morgan telescope. The roof opened like a clamshell with the help of octagonal weights. The other side housed visiting astronomers and students. While the telescope was removed years ago, guests still lodge at the facility.

The Ronnie Morgan telescope, shown here, was initially used by Kent Ford and Vera Rubin for their image tube work. They found, however, that the open roof shook when the wind blew, causing turbulence that resulted in poor observing conditions. In 1970, the 13-inch telescope was temporarily moved to Anderson Mesa. Staff then transferred the Ronnie Morgan telescope into the old 13-inch dome (shown here), where it remained until the early 1990s.

Nine

OTHER BUILDINGS

Since its founding in 1894, Lowell Observatory has maintained a charm unlike many other work environments. It is more than telescopes and offices; it is also houses and backyards, where dozens of employees have lived and raised their children. It is a place where cows once supplied milk for the residents; where children of all ages have set up tennis courts, volleyball pits, and zip-line courses; where employees enjoy picnics with their friends under the shade of a gazebo.

Mars Hill has been home to more than 10 houses and other living facilities through the years. Some still stand, some are long gone, but all have served as the birthplace of cherished memories by those fortunate to live there. This chapter looks at some of these abodes along with a smattering of other buildings, including Percival Lowell's exquisite final resting place, a granite mausoleum.

The first home on Mars Hill was built in 1894 as a place astronomers could warm up after a cold night of telescope observing. A modest five-room cottage, it served as the nucleus of a rambling residence that eventually grew to 18 rooms and was affectionately referred to by staff as the Baronial Mansion.

That structure is long gone, as are E.C. Slipher's home that burned to the ground in 1936 and the barn that housed the observatory's milk cow, Venus. But Percival Lowell's 1910 library still stands, as does Carl Lampland's home that began as a scale model sitting on the crest of Mars Hill.

Then there is the grand Slipher Building, constructed in 1916 as a do-it-all administration/darkroom/library/lodging facility. The most dramatic example of its diverse use was during Clyde Tombaugh's search for Planet X when he lived in the apartment upstairs, worked in an office downstairs, and developed his photographic plates in the basement.

As a fitting end to this book and tribute to Percival Lowell, the last photographs depict Lowell's final resting place, overlooking Flagstaff and located but 50 feet from his favorite tool of the trade, the Clark telescope.

In May 1894, while the observatory was still in its infancy, Andrew Douglass asked Percival Lowell to build a "warm room." Located just 100 feet from the dome housing the borrowed 18- and 12-inch telescopes, it was a convenient place for astronomers to stay after an evening observing run. It started with two bedrooms, a study, a workroom, and a darkroom and was called the observer's house by staff.

Over the years, the observer's house went through a number of expansions, as it became Percival Lowell's residence—staff called it the Baronial Mansion—while he was not traveling. It ultimately grew into a mansion with 18 rooms and a breathtaking view of Flagstaff. In the foreground of this photograph is the sundial that staff gave Lowell in 1905 for his 50th birthday; it now sits outside the back doors of the Steele Visitor Center.

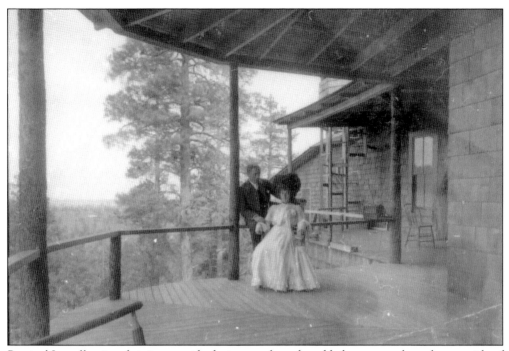

Percival Lowell enjoyed sitting outside during meals, so he added a sun porch to the east side of the building in 1898. Lowell often entertained staff at the Baronial Mansion for holidays and other special events. Here, dome porter Harry Hussey and his wife pose on the porch. Hussey worked at the observatory for seven years, beginning in 1900.

Lowell also entertained special guests at the Baronial Mansion. Shown here is physicist Albert Michelson (1852–1931) during a 1905 visit. Two years later, Michelson would become the first American to be awarded a Nobel Prize in one of the sciences. In the 1920s, he developed a technique for studying interference patterns of light that is used today at the Navy Precision Optical Interferometer, a facility comanaged by Lowell Observatory.

Eventually, bedrooms were added to the Baronial Mansion for Percival Lowell (shown here); his wife, Constance; special guests; his secretary Wrexie Leonard; and servants. After Percival died in 1916, the Baronial Mansion stood empty except for occasional visits by Constance or special guests of the observatory. By the late 1950s, it had become an irreparable fire hazard and was torn down in 1959.

In 1904, this house was built along the original road to the observatory, just above the entrance gate. Staff called it the gatehouse and later the Lodge. Several employees lived here throughout the years until 1919, when E.C. Slipher moved in with his bride, Bess. They stayed until 1936, when a pile of hot ashes outside the house ignited and burned it down. The foundation still stands.

110

Percival Lowell paid for construction of this house in 1902 as a residence for single staff. When V.M. Slipher and his wife, Emma, married in 1904, it became their home. They stayed until Slipher's retirement in 1954, at which time it became housing for visiting astronomers and was known as the Lodge.

For a short time in 1907, Carl Lampland slept in what he called the "tent house." The structure arrived at Lowell on May 1, and Lampland spent his first night there on May 25. By September, he was renting a room in downtown Flagstaff. Records are unclear about the location of the structure or why Lampland slept there, though one note suggests he stayed there while recovering from tuberculosis.

In 1913, Percival Lowell financed construction of a house for Carl Lampland and his bride, Verna. The new structure was located on the eastern edge of Mars Hill, within 100 yards of the Clark telescope dome. To help decide the exact location and orientation, Edward Mills built this model, which Lampland then set on the ground and photographed from different angles.

Here is Lampland's finished house, with Verna Lampland standing in front. The Lamplands lived here until Carl's death in 1951; Verna stayed for another year and a half. Years after Lampland died, his vast collection of books, which once filled this house, were moved to the Rotunda (see page 118) and remain there today, displayed on the balcony level.

For years, the observatory kept several cows. One of these was named Venus, and she supplied milk for the families living on Mars Hill. Around 1901, Percival Lowell called for construction of this barn for housing Venus, her fellow bovines, and horses. It was located near an open field, which allowed easy grazing for the cows.

Percival Lowell stands here next to the barn with three cows. With the advent of cars, allowing for quicker access to Mars Hill, the need for milk cows and horses was lessened. Eventually, all of them were moved off the hill, and the barn stood empty until it was torn down around 1943.

Pictured here is the original road (veering to the left) and a new road (veering to the right). This picture dates to 1938 during construction of the new road. In between the two roadways is the barn. This is the view leaving the observatory and looks much the same today, except that the road is asphalted and the barn is gone. The photograph was taken near the location of today's visitor hours sign.

Here is a close-up view of the new road during construction. It was laid quite close to the barn, and within a few years, the barn was removed. Beyond the barn, blocked from view, stood a house originally occupied by the caretaker of the cows and horses. This house was torn down in the mid-1980s and replaced with a cinder block house, which still stands.

This is another view of the new road and barn. This photograph was taken from the opposite direction of the previous ones, from a spot that would soon be covered by the road. It thus shows the basic view upon entering the observatory. Today, the barn is gone and the cinder block house sits to the right.

In 1910, Lowell built a library near the Baronial Mansion. Six years later, a new library was established in the newly constructed administration building's Rotunda. The old library building was then used for storage and later converted into living quarters, undergoing one major expansion. The structure still stands and is known as the White House, named after astronomer Nat White and his family, who lived there for more than three decades.

This is one view of the old library. Note the charred rock directly above the fireplace. The chimney never drew air well, resulting in a smoky room when a fire was lit. The building was uninsulated and very cold in the winter, so a dropped ceiling was added years later. When the building was converted into housing, this became the living room.

Here is another view of the old library. Lit display cases sat on top of concrete bases. Percival Lowell and his staff filled these cases with backlit images of planets, stars clusters, the moon, and other celestial images captured through the observatory's telescopes. On top of the bookcase sits a photograph of the Sombrero Galaxy, the first spiral nebula V.M. Slipher detected to be receding.

About 1901 or 1902, the observatory built a water tank south of the Clark telescope dome and installed this pump house near the bottom of Mars Hill. Water from Flagstaff was pumped from the pump house up the side of Mars Hill and into the tank. Remnants of this pump house remain and are easily visible at the first sharp turn of Mars Hill Road, the road leading up to Lowell.

This gazebo used to sit on the crest of Mars Hill, 75 yards northeast of V.M. Slipher's house. The site is now occupied by a house built in 1965 for astronomer William Baum and later home to directors Robert Millis and Jeffrey Hall and their families. Bill Putnam later built a modern gazebo along the Pluto Walk, the walkway leading up to the 13-inch dome.

After the observatory had been in operation for about 20 years, Percival Lowell decided to construct an administration building to serve as the center of business activities. He commissioned his cousin (and future sole trustee) Guy Lowell to design a building that would sit 100 yards north of the Clark telescope dome. This model indicates the early vision for the structure.

The main or administration building, as it became known, featured a circular dome (the Rotunda) flanked by wings off the eastern and western sides. In this photograph, laborers work together—some pushing, others pulling—to elevate lintels into place. The interior walls of the Rotunda were made of brick and then covered with plaster and painted.

The top of the Rotunda consisted of a wooden framework covered with wooden planks bent to adhere to the rounded shape of the framework. The workers rigged a number of scaffolds and platforms, both inside and outside the Rotunda, to access the places that rose 30 feet above the ground.

After the entire top of the Rotunda was covered with wood, a layer of soldered metal was added, giving a shiny appearance that resembled a telescope dome. At the apex of the dome, workers installed a skylight (not visible here) to help illuminate the interior of the Rotunda during the day. While the Rotunda was visually stunning, it often leaked through the skylight and along the metal seams.

Here is the finished main building in 1916. It had a basement that housed darkrooms, storage rooms, a bank-type vault, and the furnace. The ground floor held offices, while the Rotunda would serve as the new library. Like the Rotunda, the roof of the wings leaked terribly, so plans were made to add another story to be topped with a pitched roof.

This corner of the main building was dedicated for use as the director's office. As seen here, it originally opened to a roofed porch in the far corner, but this was eventually enclosed and used for storage and meeting space. As with several other facilities on Mars Hill, the exterior walls of the main building were faced with volcanic Malpais rock.

A second story was added in 1923, topped by a pitched roof that allowed for plentiful attic space. The pathway in this photograph was later paved and served as the main entrance to the observatory until the Steele Visitor Center was built in 1994. In 1989, Bill Putnam officiated a rededication ceremony of the main building, officially naming it the Slipher Building in honor of V.M. and E.C. Slipher.

This 1947 photograph shows the interior of the Rotunda when it housed the library. Bookshelves line the floor and the balcony above. In the foreground to the right is the Mars Lamp, inlaid with drawings of Mars. Hanging from the middle of the domed ceiling is the Saturn Light. This was a special-order lighting fixture built just after World War I that resembles the planet Saturn.

On November 12, 1916, Percival Lowell suffered a stroke while at the Baronial Mansion and died. Only 61 years old, he had lived a full life and made important contributions in several fields, particularly astronomy and Orientology. A year after Lowell's death, his former secretary Tsunejiro Miyaoka paid his respects by visiting Lowell's grave. Lowell's car, Big Red, sits in the background.

This photograph of Lowell's grave gives a general idea of its location on the eastern edge of Mars Hill, overlooking Flagstaff. It was located along the ridge between two of Lowell's most cherished buildings, the 24-inch Clark telescope dome and the Baronial Mansion. He would remain buried here for several years while a mausoleum was built.

A second view of Lowell's grave shows not only its proximity to the Baronial Mansion (building to the far left) and old library (just to the right of the Baronial Mansion) but also how close the buildings are to each other. In the background, Mount Elden is to the far right, rising over a barren plain now covered with homes and businesses.

At the Mount Auburn Cemetery in Cambridge, Massachusetts, Percival's family honored him by erecting a cenotaph made out of petrified wood at the family plot. In Flagstaff, Lowell's widow, Constance, decided to build a mausoleum at the observatory. The project would not get under way until 1923, seven years after Lowell's death. Here, a worker hoists a section of cut stone into place.

The walls of the mausoleum were built of granite mined from a quarry in Quincy, Massachusetts, that famously supplied rock for the Bunker Hill Monument in Charleston, Massachusetts. On top of the walls sat a rounded metal framework that was then covered with rows of cobalt-blue glass squares.

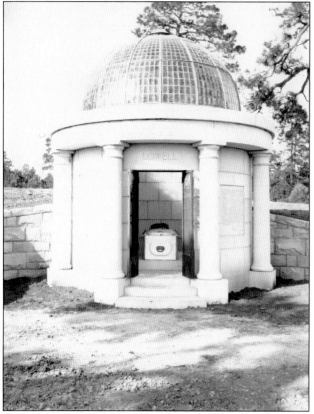

Construction of the mausoleum took place in 1923. The finished building stood on a rock-lined flat of land dug out of the hillside and accessed by steps on either side. Above the door, workers inscribed the name Lowell. Two of Lowell's most provocative quotes were etched into the granite on both sides of the door. Inside, the building was empty except for Lowell's white coffin, shown here.

The mausoleum lies near the Clark telescope, the instrument Lowell used for most of the Martian research that led to his worldwide fame. The legacy he built while alive was closely linked to this instrument, so it is only appropriate that his remains lie forever enshrined along the same ridge, sharing the same air, as his telescope.

In 1974, observatory staff decided to seal Lowell's coffin in a granite sarcophagus. While the reason for doing this is uncertain, one well-told tale might explain it: years earlier, a visiting family noticed blood trickling out of the mausoleum; close examination by staff revealed the "blood" to be rust from the coffin. Enclosing the coffin in rock solved this rather disturbing problem.

ASTRONOMY NOW DEMANDS BODILY
ABSTRACTION · OF ITS DEVOTEE ·
· · TO SEE INTO THE BEYOND RE·
QVIRES PVRITY · · AND THE SECVR·
ING IT MAKES HIM PERFORCE A
HERMIT FROM HIS KIND · · · ·
HE MVST ABANDON CITIES AND
FOREGO PLAINS · · · · ONLY IN
PLACES RAISED ABOVE AND ALŒF
FROM MEN CAN HE PROFITABLY
PERSVE HIS SEARCH · HE : MVST
LEARN TO WAIT VPON HIS OPPOR·
TVNITIES AND THEN NO LESS TO
WAIT FOR MANKIND'S ACCEPTANCE
OF HIS RESVLTS · · FOR IN COM·
MON WITH MOST EXPLORERS HE
WILL ENCOVNTER ON HIS RETVRN
THAT FINAL PENALTY OF PENETRA·
TION THE CERTAINTY AT FIRST
OF BEING DISBELIEVED · · · · ·

MARS AND ITS CANALS
PERCIVAL LOWELL

The two quotations on Lowell's mausoleum serve as an appropriate tribute to this multifaceted individual whose mastery of the English language is evident in the dozens of books, magazine articles, and newspaper articles he wrote. From his book *Mars and Its Canals* comes this compelling interpretation of the astronomer as an explorer.

This passage from Lowell's 1909 book, *The Evolution of Worlds*, can serve as his own epitaph—this from the man whose passion for exploring the universe was matched by his desire to share it with the public, ideals that inspired him to put his money where his mouth was and build this observatory, which stands as his everlasting monument.

EVERYTHING AROVND THIS EARTH
WE SEE IS SVBJECT TO ONE INEV·
ITABLE CYCLE OF BIRTH GROWTH
DECAY · · · NOTHING BEGINS BVT
COMES AT LAST TO END · · · ·
THOVGH OVR OWN LIVES ARE TŒ
BVSY TO EVEN MARK THE SLOW
NEARING TO THAT EVENTVAL
GOAL · · · · · TODAY WHAT WE
ALREADY KNOW IS HELPING TO
COMPREHENSION OF ANOTHER
WORLD · IN A NOT DISTANT FV·
TVRE WE SHALL BE REPAID WITH
INTEREST AND WHAT THAT OTHER
WORLD SHALL HAVE TAVGHT VS
WILL REDOVND TO A BETTER
KNOWLEDGE OF OVR OWN AND
OF THE COSMOS OF WHICH THE
TWO FORM PART · · · ·

THE EVOLVTION OF
WORLDS ·
· PERCIVAL LOWELL

BIBLIOGRAPHY

Hoyt, William G. *Lowell and Mars.* Tucson, AZ: University of Arizona Press, 1976.
———. *Planets X and Pluto.* Tucson, AZ: University of Arizona Press, 1980.
Lowell, Abbott L. *Biography of Percival Lowell.* New York, NY: MacMillan, 1935.
Putnam, William L. *The Explorers of Mars Hill.* West Kennebunk, ME: Phoenix Publishing for Lowell Observatory, 1994.
Schindler, Kevin. *100 Years of Good Seeing: The History of the 24-inch Clark Telescope.* Flagstaff, AZ: Lowell Observatory, 1998.
———. *E.C. Slipher's Mars Expeditions to South Africa.* Monthly Notes of the Astronomical Society of Southern Africa, 66 (7 & 8): 145-156.
Sheehan, William. *Planets and Perception: Telescopic Views and Interpretations, 1609–1909.* Tucson, AZ: University of Arizona Press, 1988.
———. *The Planet Mars: A History of Observation and Discovery.* Tucson, AZ: University of Arizona Press, 1996.
Strauss, David. *Percival Lowell: The Culture and Science of a Boston Brahmin.* Cambridge, MA: Harvard University Press, 2001.
Way, Michael, and Deidre Hunter, eds. *Origins of the Expanding Universe: 1912–1932.* Astronomical Society of the Pacific Conference Series 471, 2013.

DISCOVER THOUSANDS OF LOCAL HISTORY BOOKS
FEATURING MILLIONS OF VINTAGE IMAGES

Arcadia Publishing, the leading local history publisher in the United States, is committed to making history accessible and meaningful through publishing books that celebrate and preserve the heritage of America's people and places.

Find more books like this at
www.arcadiapublishing.com

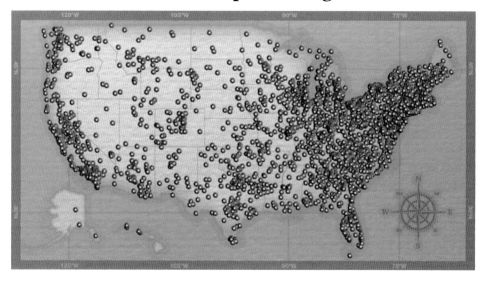

Search for your hometown history, your old stomping grounds, and even your favorite sports team.